Lighting and the Dramatic Portrait

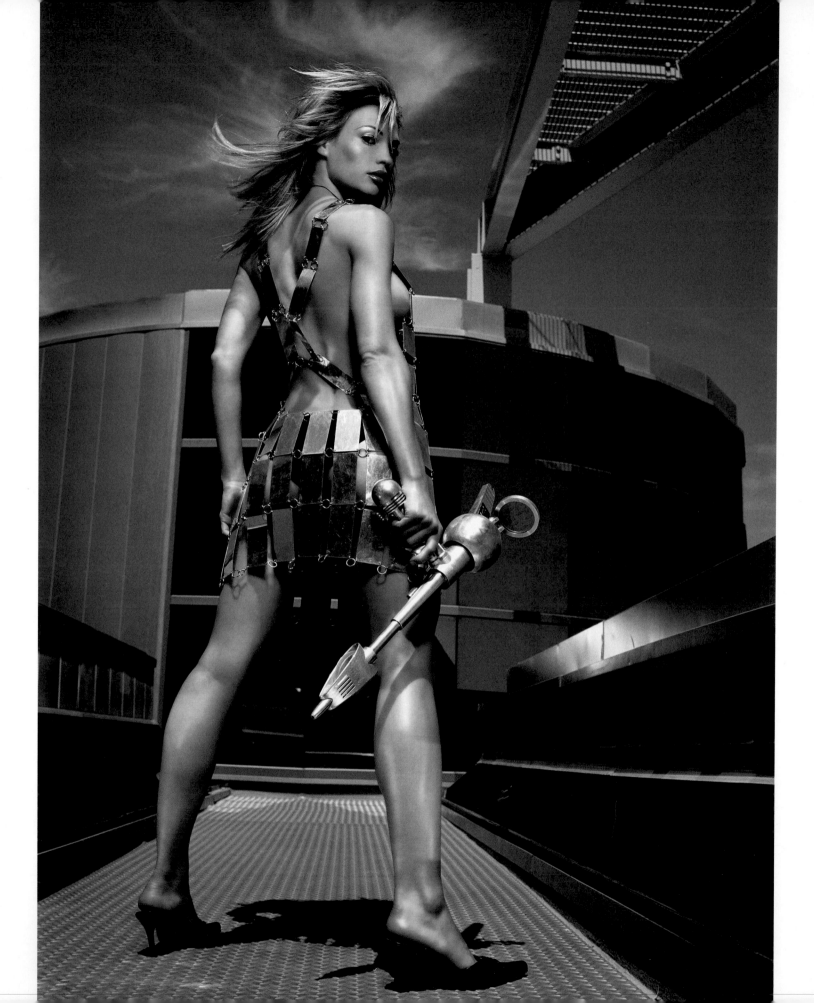

Michael Grecco

Lighting and the Dramatic Portrait

AMPHOTO BOOKS

AN IMPRINT OF WATSON-GUPTILL PUBLICATIONS / NEW YORK

Editorial Director: Victoria Craven
Editor: Martha Moran
Designer: Pooja Bakri, Bakri Design
Technical Editors: Pamela Parlapiano, Steve Inglima,
Jared Mechaber
Illustrators: Nicolas Hawken, Sivan Earnest

First published in 2006 by Watson-Guptill Publications
a division of VNU Business Media, Inc.
770 Broadway, New York, N.Y. 10003
www.wgpub.com

Library of Congress Cataloging-in-Publication Data

Grecco, Michael.
 Lighting and the dramatic portrait / Michael Grecco.
 p. cm.
 Includes index.
 ISBN-13: 978-0-8174-4227-9
 ISBN-10: 0-8174-4227-8
 ISBN-13: 978-0-8174-4223-1
 ISBN-10: 0-8174-4223-5
1. Portrait photography–Lighting. 2. Celebrities–Portraits.
I. Title.
TR575.G75 2006
778.9'2–dc22

 2006010244

Manufactured in England

First printing, 2006

1 2 3 4 5 6 7 8 9 / 14 13 12 11 10 09 08 07 06

This book is dedicated to my children, Dakota, Sophia, and Zoey, and to the memory of Chris Farley for one of my most memorable shoots.

Contents

A Note from the Author

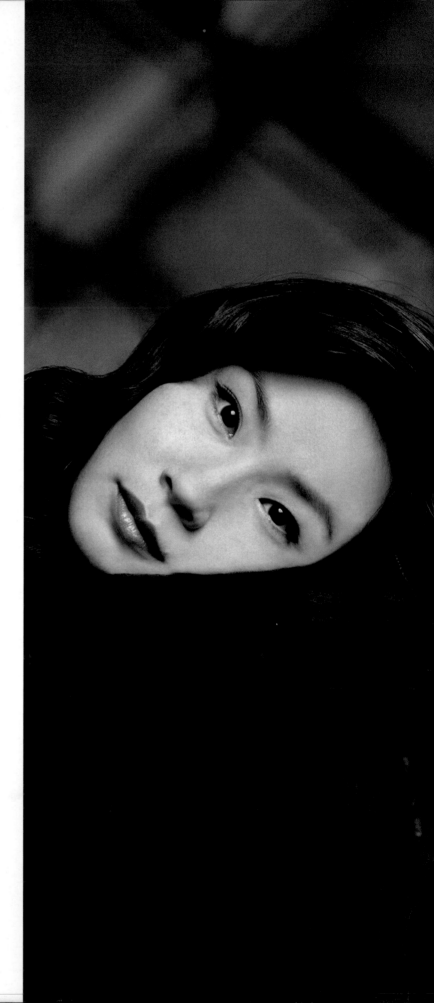

This book is an attempt to make both a monograph of my images, and create a sort of portrait photography course by talking about my approach to my work. Because I am using my photographs as examples for various techniques and lessons, I have included a wide variety of images that might not normally be put together—or placed in this sequence.

Assistants and other photographers have asked why I would want to give away my secrets in a book. But I don't see it that way. I am just passing along what I have learned through years of experience, along with some insights about my process that I hope will help you perfect your own. I believe the most important thing you can take away from this book is how I discovered what worked for me. No one can get inside my head and think the way I think—in the end, we all make our own discoveries. The techniques described here are not all my secrets; I have learned a lot from being on film sets and talking to other photographers. If I had relied on a set of fixed rules and principles throughout my career, my work would have been repetitive, it would not have evolved and improved, and I would have become bored and stale. I continually look for new ideas and new ways to handle different situations, trying out new lighting solutions, camera "tricks," and overall approaches. Think of this book as a starting point for your own creative process. Remember the old joke? Question: "How many photographers does it take to change a light bulb?" Answer: "Fifty-one to change it and fortynine to say how they would have done it differently." So, experiment, see what works, take chances, and most of all, enjoy!

Michael Grecco

This image of Lucy Liu was shot in the Thom House, a beautiful estate in the Holmby Hills area of Los Angeles. I placed her up on a balcony and had her drape herself on the rail as I shot her from below.

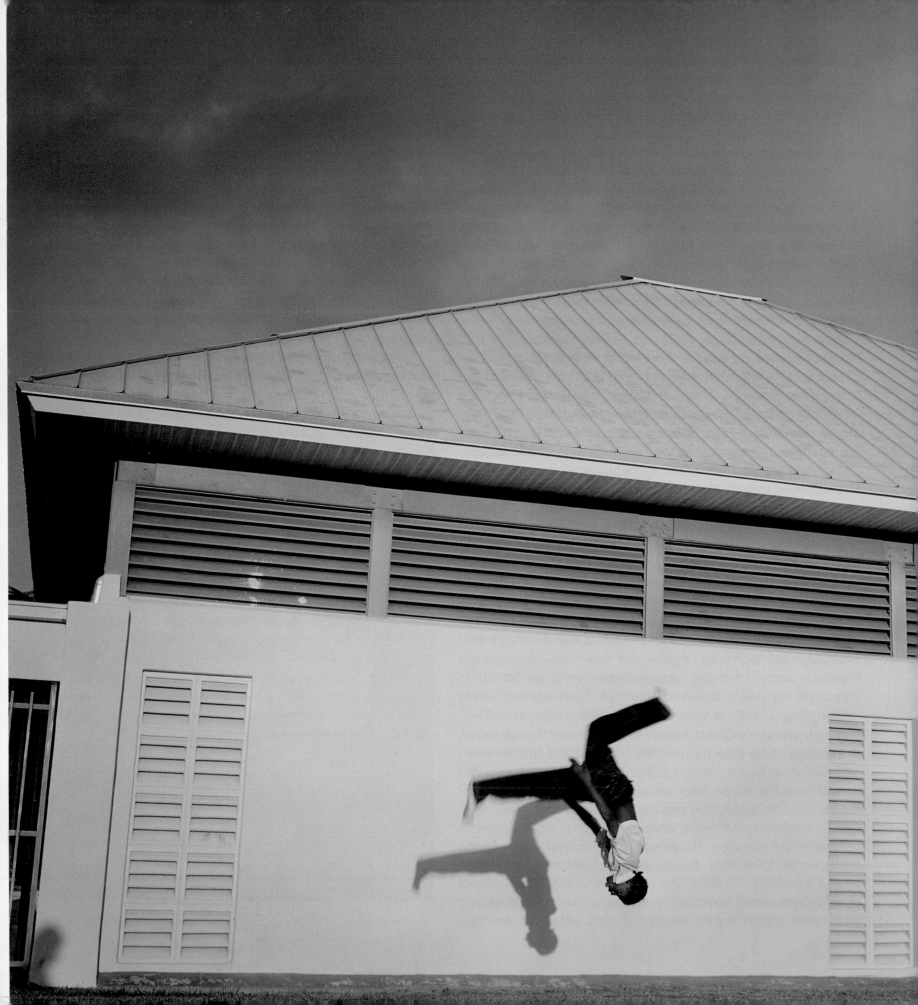

Cameras

Formats & Lenses

Every camera format has its advantages and disadvantages and each can be used like a carpenter's chisel—the right camera format for the appropriate job. In my opinion, when it comes to photography, size does matter! Choosing a format is the first decision I have to make when approaching a shot. (The second is matching the right lens to the selected film.) Each camera format has its own set of focal-length lenses and effects the lens choices that will be available to me. You'll also need to consider the film that can be used for each format considered.

35mm cameras

A 35mm camera is perfectly suited for shooting action and photojournalistic images. The ability to hold it in your hand allows you to easily move around your subject and quickly capture the subject's movements and expressions—to get the "grab" shot. The automatic focus on most of these cameras is so accurate that you don't even have to look through the viewfinder to shoot something off the cuff. A 35mm camera can also make the shoot more diversified, permitting more varied coverage simply by moving your body around—coming in tight one moment and backing up the next; quickly transitioning from shooting vertical to shooting horizontal; and moving around all sides of the subject. I particularly like using my Canon 35mm gear with a 300 f/2.8 lens for these types of shots. It gives me the ability to follow along with the subject while keeping him or her in focus. The long focal length of the lens allows me to "soften" the background with the shallower depth of field of a long lens, and the camera's agility gives me the ability to easily shoot different angles to supplement the "main" shot I take with the medium- or large-format camera. I often use my 35mm to shoot under the modeling lights of the strobes to this purpose.

With the relatively new sophistication of today's SLR cameras, such as Canon's flagship 1DS-Mark II (the resolution power of the 16.7 CMOS chip rivals medium-format film), I get the convenience and versatility of a 35mm system with the resolution quality of a medium-format camera. Digital technology today renders excellent skin tones and superior color management in a fast and stable package.

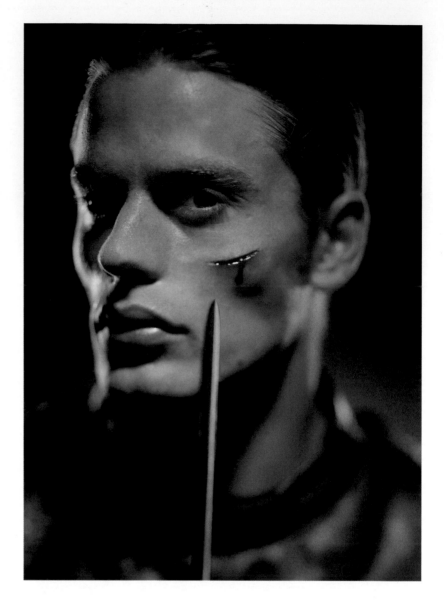

These are two images for the *Men's Health Best Life* magazine. The story was about a group of German fencers who "fence to draw blood." The image of the fencer with the cut below his eye is the preconceived, set-up image, carefully crafted in its lighting and camera positions, and photographed with a Fuji 680 medium-format camera with a 125mm lens. The other (with the cut above the eye) was shot under the available light from the modeling lights of my Dyna-Lite strobes using my 35mm Canon EOS 1Dn. Using the 35mm format, I was able to purposely add some motion into the shot by moving the camera to work a wider range of angles very quickly. The expression I caught on the 35mm helped make the image work and was eventually used in the article instead of the set-up shot. Most importantly, the 35mm allowed me to experiment as I shot, creating variety and increasing my options.

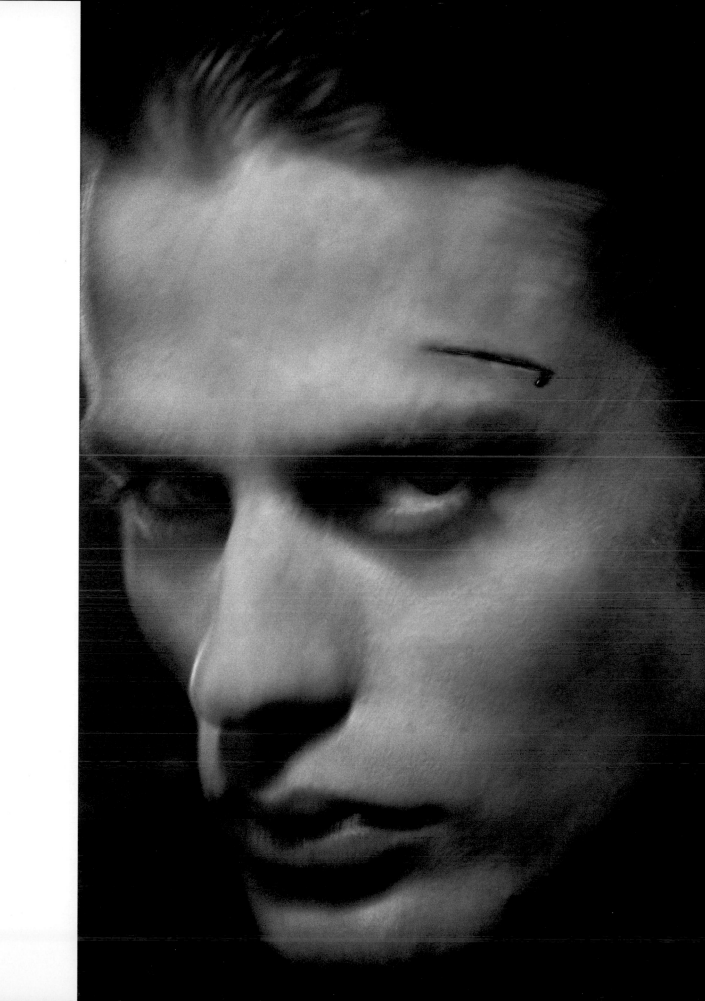

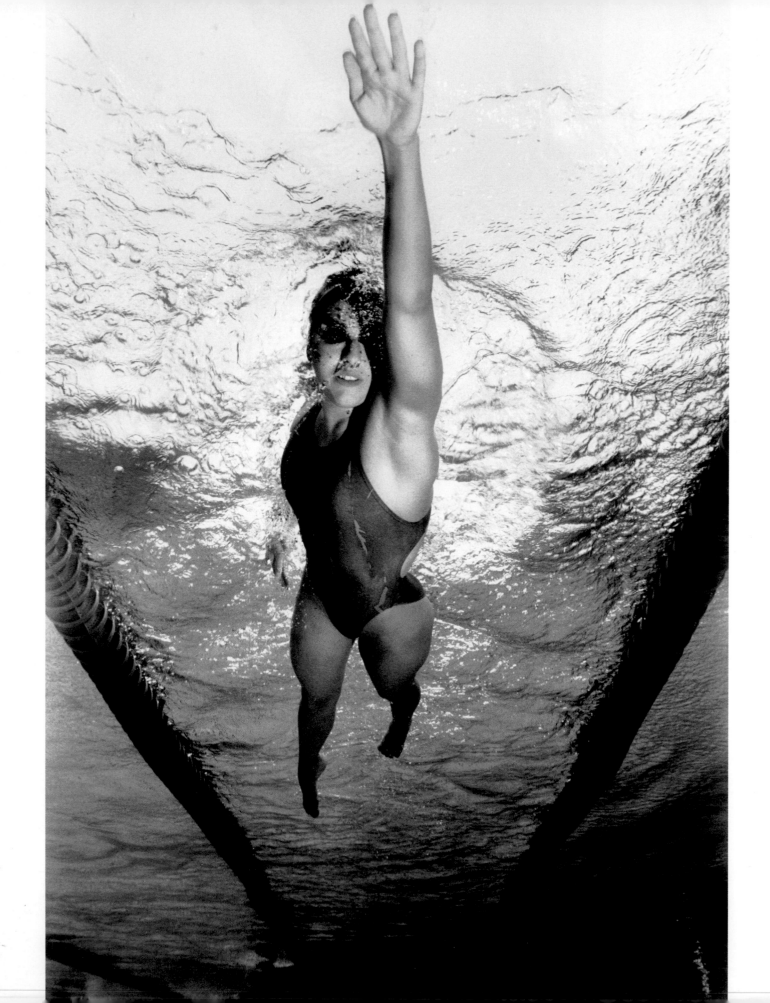

Medium Format

Medium format is any camera that uses 120/220 roll or instant pack (i.e., Polaroid) film. As someone who shoots portraits, I am particularly fond of this format. The photographer makes a statement when a camera of substantial size is set up at a shoot. Your subject knows it's a real shoot, not just someone walking in and "snapping" a photograph

Medium-format cameras can be relatively small, such as a 6x4.5 system, or as big as a 6x17 panoramic camera. The most popular formats are 6x4.5, 6x6, and 6x7. I like to use the Hasselblad H1 system (which is 6x4.5) because of its auto-focus and its small, easy-to-hold size (I often hand-hold it like I would my 35mm.) I also use a Fuji 6x8 camera because its tilt-and-shift feature, like that of a 4x5 large-format camera, enables you to control which things are in focus in the frame.

The nice thing about a medium-format system, as opposed to large format, is that it uses roll film. This is vital when time is of the essence, but you still want the quality of a bigger negative. When you shoot roll film, you can almost always capture that "second moment" shot you might miss while changing 4x5 or 8x10 sheet-film backs, checking the focus, and pulling the dark slide of a large-format camera.

With all of my medium-format cameras, and sometimes with my large-format 4x5 Graflex SLR, I take them off the tripod, move around a bit, and explore new and different perspectives while shooting. You can't be 100 percent sure of what works until you look at it on film. On many shoots, I thought I would get the best image with my starting set up, only to find that the shots improved as I moved around and experimented. This process of discovery and experimentation gives me a greater depth of knowledge and intuition to use on future shoots.

An aesthetic benefit of medium format that I particularly like is that the lens lengths increase with the increased size of the film. If a 35mm or 50mm lens is "normal" (no magnification or demagnification) on a 35mm-format camera, then 80mm or 90mm lenses are "normal" on a medium-format camera. As the focal length increases there is greater lens compression and shallower depth of field, which, I feel, is much more pleasing to the eye.

Last but very important is that most medium-format cameras can be modular, i.e., the lens, body, and film back are all separate units. This might seem like a minor detail, but a Polaroid back enables you to preview your image on instant film before you shoot it on roll film. This previewing process has taught me a lot about lighting, and helped me develop my style as a photographer. It gives me the ability to make choices in the field, as I shoot, instead of wishing I would have shot it differently after I look at the film in the studio. Previewing also tells me if the camera and lens are functioning properly for the shoot. There have been several big shoots where I was able to avoid potential problems because the preview Polaroid told me in advance that the camera was not working properly—something that can mean the life or death of the shoot.

This image of four-time Olympic gold (and one-time silver) medalist Janet Evans, created for a special Summer Olympics edition of *Newsweek*, could only have been shot using the underwater 35mm format. I started with some dramatically lit, but straightforward portraits of Janet above the water using a Hasselblad 6x6 medium-format camera. I dive, so I rented scuba gear and an underwater 35mm camera so I could shoot Janet swimming from a bottom-of-the-pool perspective as well. The pool was quite deep, so to get the underwater strobe close enough to Janet, and to generate underwater light powerful enough to match the exposure of the sky though the water, I used the extra height of a C-stand arm on a light stand, put the strobe on top of it, and placed it at the bottom of the pool, weighting it down with a sandbag. I put my weight belt on the bottom of the pool and tied myself to it so that I was at the same height every time she swam by.

After shooting one roll of color, Janet, who was in training, said she needed to leave. I had brought along a roll of black-and-white infrared to try and I begged her to let me shoot one more roll—she agreed. Because we had so little time, I had to load the one underwater camera outside, in the heat, in a changing bag. (This is not a trick Kodak would recommend. Infrared film should be loaded in a dark room in a changing bag, and for good reason.) As a result, this was the only frame out of the half-roll she let us shoot that was not fogged! As I always say: Go for it! You never know when you'll catch that one great image.

Shutter + Aperture = Control

Too often when I shoot, the first words out of the assistant's mouth are: "What f-stop do you want?" While this may seem an elementary question, it's not the first question you should ask. Before you know what f-stop you want, you first have to know what it is you are trying to accomplish in the photograph: Do I want to freeze action, or show motion, and consider shutter speed, or, do I need to get a cast of people in focus, or focus selectively, and cater to aperture?

I have to stress here that the aperture and shutter speed you choose is both a practical *and* an artistic decision. The practical part is simple: "Can I hold the camera steady if I don't have a tripod and want to hand-hold it?" Or, "Will the settings provide enough depth of field to get the entire group of people in focus?" The artistic considerations aren't quite as obvious. Some motion in a shot will create an atmosphere that's "soft" or will imply action, depending on how it's controlled (i.e., how slow the shutter is, and which direction the camera is moving in relation to the moving subject). To figure all this out, I often squint at what I am shooting or picture it in my mind's eye. I try to come from a place of intuition (knowing what I want), and discovery (being open to new things). I let that combination tell me what will work and what won't, and then I preview the shot with a Polaroid, or, if I am shooting digitally, on a large computer monitor.

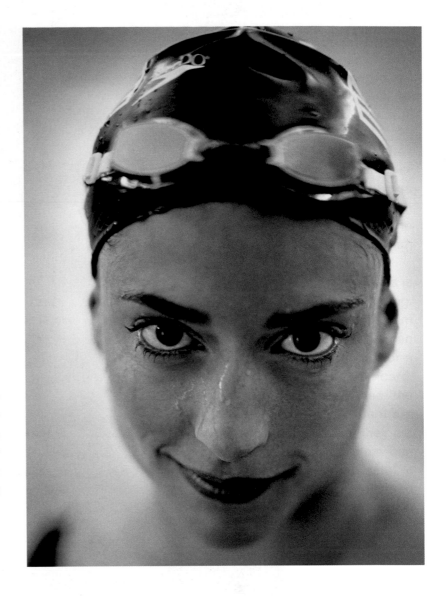

These two images of the Olympic hopeful Rochelle Fox help illustrate the use of wide aperture (very little depth of field) and a slow shutter speed to create motion. In the close-up image, I loved the way the available light looked as she got out of the water. It was backlit, which differs from the way I normally light, so I was attracted to the uniqueness of it. The background in this shot was terribly confusing and chaotic. I put my camera on a tripod (to avoid camera shake) with the mirror open. I then chose the fastest shutter speed (1/8th of a second). Given the widest aperture, I had to make the background go completely out of focus. For the motion shot, I needed to slow the shutter speed down enough (1/15th and 1/30th) to get the motion of her arms and legs, yet still capture the detail in her face. I used the motor drive on high speed and panned the camera as she swam below me; it was just enough to capture the combination of movement and sharp focus.

These images are also great examples of the benefits of having various camera formats at your disposal on every shoot. The set-up shot was taken with a medium-format camera and the action shot while handing off the diving board was taken with a Canon 35mm.

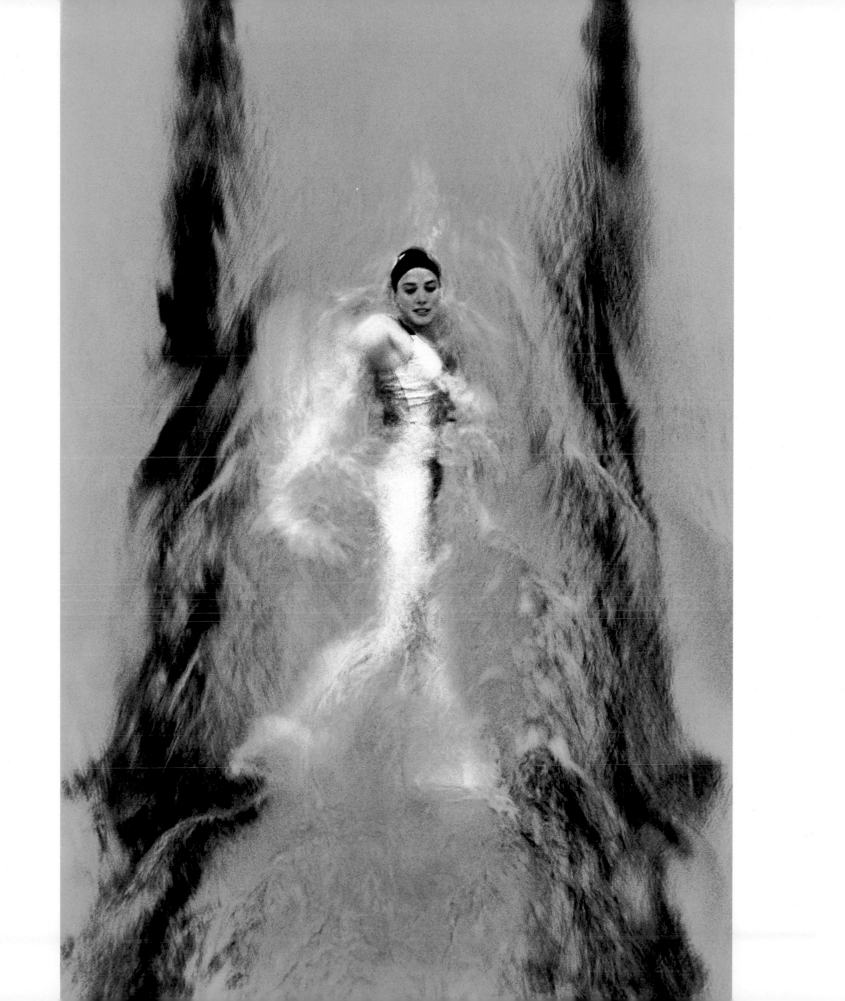

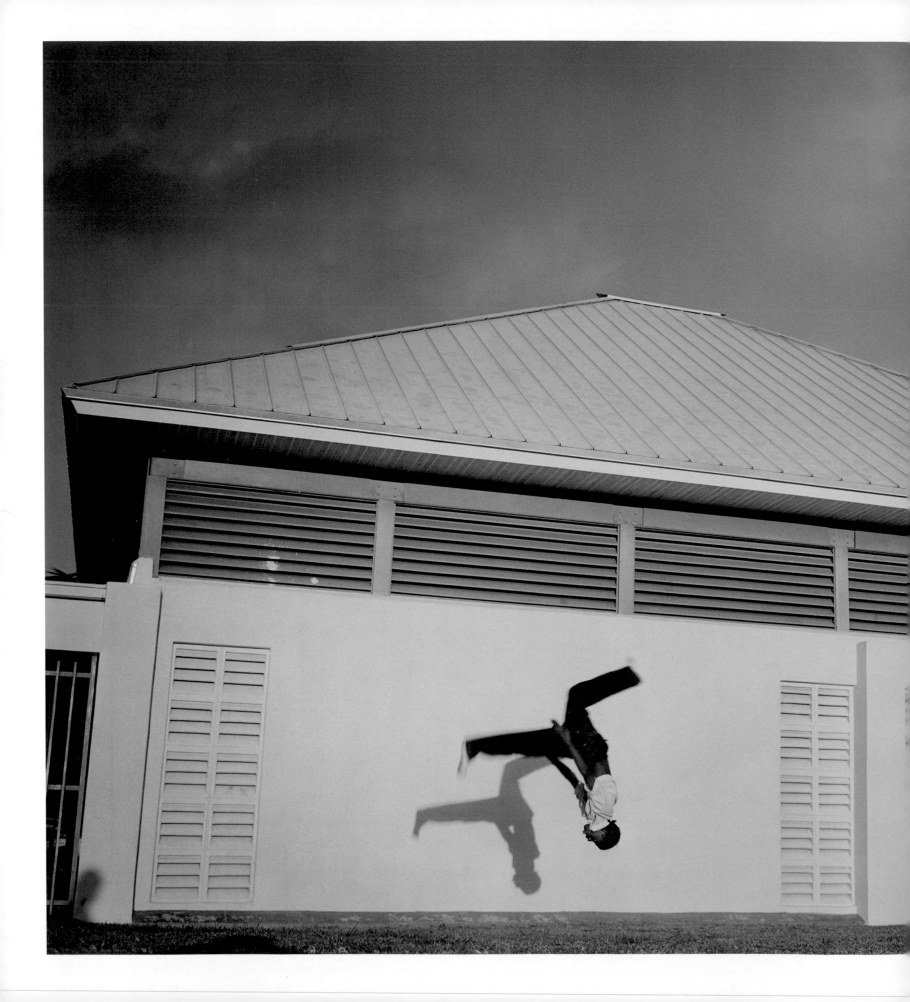

Life is funny. You have to put yourself out there to be open to good things that happen. When you do, great images sometimes just fall into your lap. Once, as I was walking around shooting in Miami, a kid approached me and said, "Hey, my buddy can do amazing somersaults!" I said, "Show me!" Duly amazed at what I saw, I set up this photograph. This kid was actually a gymnast with hopes of being in the Olympics one day. To freeze his somersault in midair, I chose a high shutter speed to stop his motion and a wide (smaller number) f-stop. I set the shot against this very sturdy building to create juxtaposition between the moving subject and the stationary background. His body had to be in sharp focus to look like it was defying gravity; if it had motion blur, the impact would have been lost. I kept all the information in the image in the same plane of focus because I had very little depth of field but wanted a crisp image. I added a warming gel to the lens because I wanted the look of sunset, but was worried that my shutter speed would be too slow to get the motion in sharp focus if I shot in low-light conditions.

Motion Blur

Motion blur can be used to create excitement, mood, or the feeling of action. Using the appropriate light source and shutter speed allows you to capture motion blur with some control. A Polaroid or a color-calibrated monitor will give you the ability to preview the amount of motion you create as you slow the shutter down or mix continuous light with strobe. For even more control, I will also often bracket the shutter to make sure that I get slightly varied degrees of motion. Remember, you often cannot re-shoot a job or celebrity who has an extremely busy schedule, so you have cover all your options. To get the right amount of motion here, I put my Canon camera on "Automatic" and selected "Aperture Priority". I bracketed the f-stop knowing the camera would make subtle changes in the shutter speed as I bracketed and as the details in the images changed the exposure subtly. This way I was certain to get variations on the images and capture the one with the right amount of motion.

This image was shot during a cover session for *USA Weekend* and it was the second time I had photographed Shaq. The magazine needed a very simple portrait against a seamless backdrop. We were shooting at Shaq's home and had just finished environmental shots for the inside story; for the cover, I wanted to do something more fun for Shaq, and for myself. I had always been struck by the "big kid" sensibility Shaq has and I wanted to capture that. While I shot the setup of Shaq with strobe against a seamless, I had an assistant load a roll of Kodak Tri-X in my Canon camera so I could also shoot his expressions under the modeling light, get some movement, and capture his spontaneity. To get the right amount of motion here, I put my Canon camera on "Automatic" and selected "Aperture Priority". I bracketed the f-stop knowing the camera would make subtle changes in the shutter speed as I bracketed and as the details in the images changed the exposure subtly. This way I was certain to get variations on the images and capture the one with the right amount of motion.

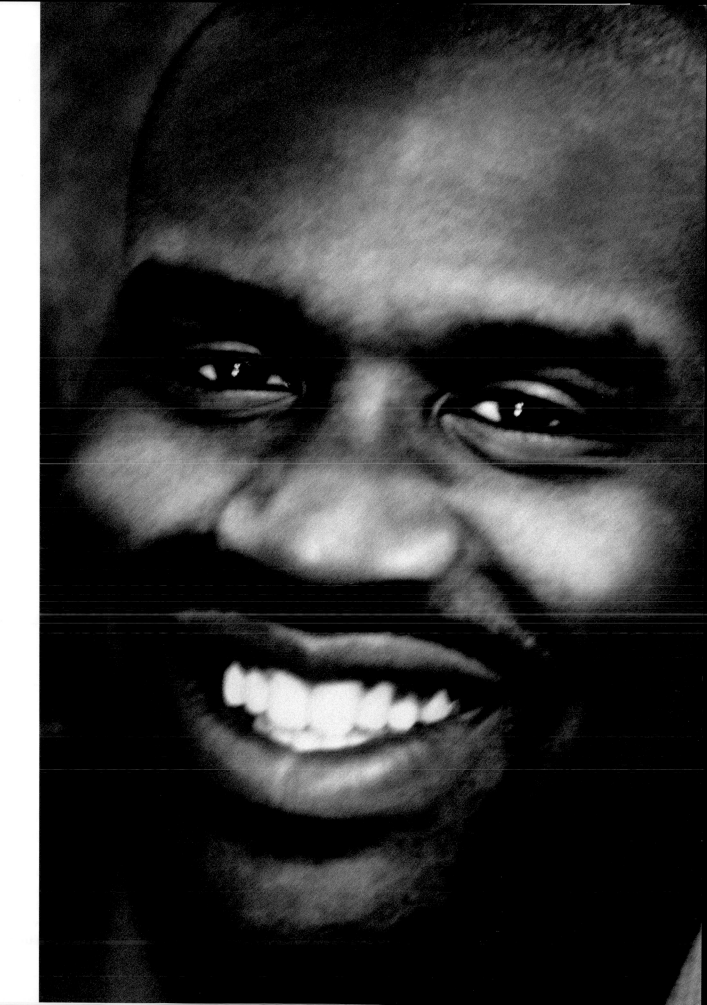

wh
we
sh
oth
oth

In
an
ch
er
sh

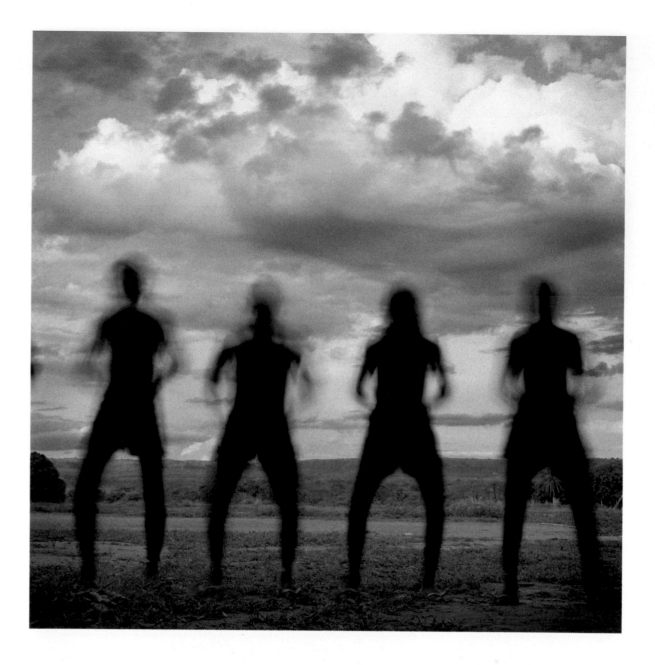

Capturing the motion blur in this image required inspiration, a lot of patience, and a calm, steady hand. The Brazilian metal band, Sepultura, traveled to the middle of Brazil to record an acoustic song with the Xavantes Indians, and I met them there to shoot images for an album cover and packaging. The journey to this extremely isolated village was amazingly long and complicated, and to this day, I don't know where, exactly, I was. Water and lighting equipment arrived the next day on a separate plane, and the videographer and I could not bring assistants, so I found myself making images that night by flashlight. The next afternoon, Sepultura played under a mango tree, while the Indians sang a meditative chant as they danced back and forth around the band. It was incredibly moving and very spiritual. I wanted to capture this deep emotion in the movements of the silhouetted figures. If the light had been very low,

I could have done this by using a long exposure (maybe a few seconds) to get some great blurring. But, it was the middle of the day, so I had to come up with another solution. Then it came to me. A blur is like lots of little exposures all added up. I could make six or eight multiple exposures on the same piece of film and get the same effect as I would from low light and a long exposure. I previewed my idea on Polaroid and it worked! I set up the camera on a small tabletop tripod, calculated the f-stop for six exposures on one piece of film, and started shooting. I meditate, so I used those techniques to keep myself calm and methodical as I very, very carefully removed the film holder after each frame, let the camera wind, and put the film holder back on. I also changed the number of multiple exposures on each frame periodically to bracket the film exposure.

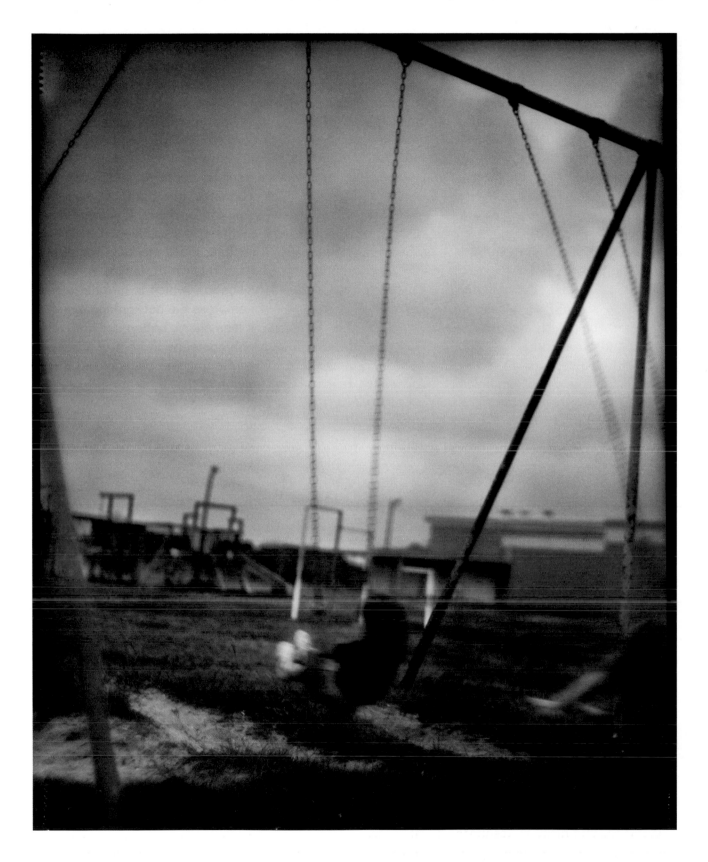

I liked the moody sky and the graphic nature of all the lines this image, shot on a road trip through Texas. Since the graphic qualities, not the subject, were of primary interest to me, I let the kids on the swings blur by using a slow shutter speed. This blur effect was enhanced even more by all the jumping around I did as I tried to avoid the annoying mass of mosquitoes biting my bare legs. Sometimes you just have to know when to go with the flow.

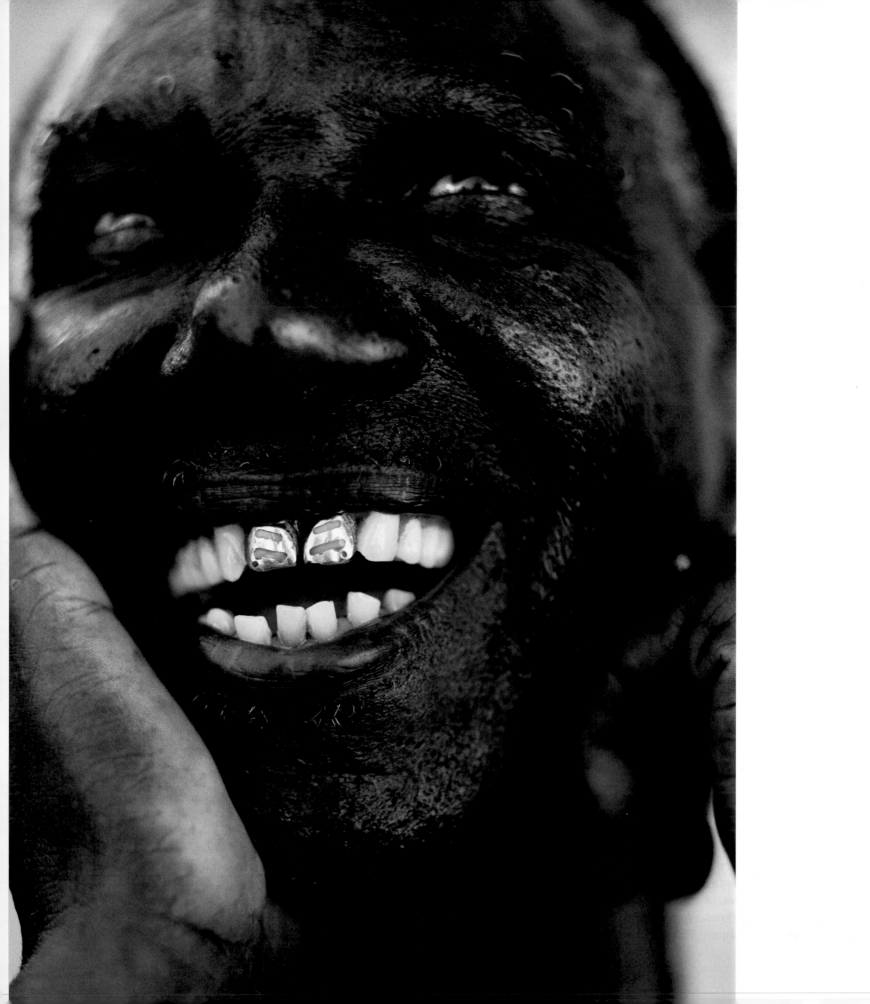

Plastic Cameras

As a kid, I was blown away every time I saw photos that were shot with a Diana Camera (an inexpensive, plastic model with only one setting). I love the mystery and magic of a Diana image—the sharp focus in the center, and the soft background that falls off into darkness at the perimeter of the image. The Diana requires bright daylight that must hit the subject from the "right" direction, which can be a challenge since you can't move the sun around to wherever you need it. You can't use a strobe with it, and it doesn't work well in the shade. I never managed to find the right conditions to use a Diana on a shoot.

Then, I discovered a small, inexpensive camera like the Diana that could sync with a strobe and had a hot shoe—the Holga. The Holga is a $10–$20 plastic camera, made in China, and its optics are unpredictable at best. Most images taken with a Holga "fall off" into darkness at the edges and are a little soft everywhere but the center, a lyrical yet not technically "perfect" image. The irony here is that though the Holga costs under $20, the hot-shoe adapter you need to use a PC cord and professional strobes with it is $60!

The challenge of using the Holga is that the shutter speed and f-stop are fixed, for the most part. There is only a one-stop difference between the "sunny" setting and the "shade" setting (pictographs are included on the lens for your added excitement). Holgas come with a 6x4.5cm mask which gives you additional frames out of a roll of film, but the mask crops out most of the cool-looking objects in the corners, so I always take out the masks and throw them away. There is even a new model Holga with a Polaroid back attached, making previewing a breeze.

Every year, I like to take a road trip to shoot personal images—one year, I went to Key West to see what it was all about, photographically speaking. A friend told me about a colorful local character named Fuzzy the Shoemaker. I was intrigued, looked him up, and shot him one of the first days I was in town. The techniques I used that day were very typical for me: I lit his face dramatically with strobe and shot with lots of depth of field. Though this method has been tried and true with me, I spent the next few days looking at the Polaroid not knowing quite what was "wrong" with the image. I went back to see Fuzzy on my last day in Key West and decided to shoot him with natural light instead of strobe. The natural light gave me very little depth of field and I had to use a very tight focus in the shot. The obvious focal point was his gold-plated teeth, of which he was so proud. The subtle selective focus here rivets the eye on Fuzzy's teeth because they are in sharp focus, in contrast to the softness of the rest of his face. I used selective focus here to portray an important aspect of Fuzzy's persona and to create a more complex image.

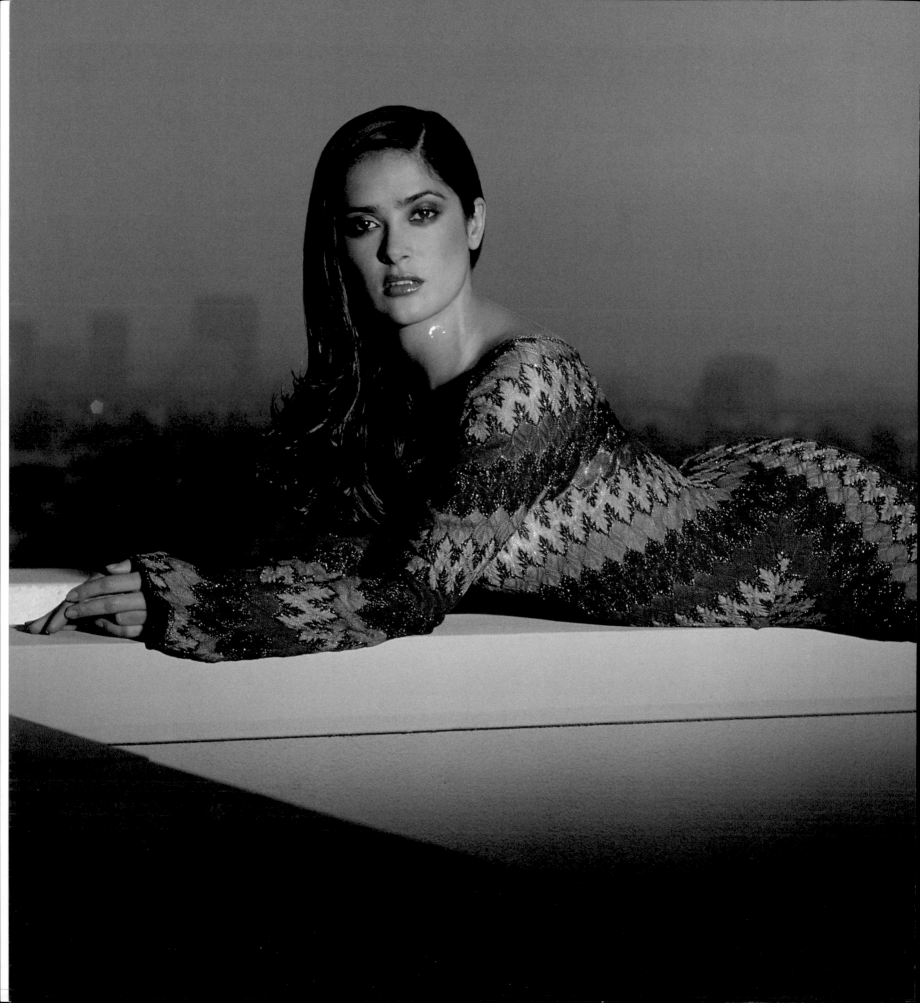

Illumination

The Color of Light

Subject: Miami Fashion Story I **Usage:** Fashion spread, *Ray Gun* magazine
Client: David Carson, Creative Director **Lighting:** Ambient light with softbox fill
Camera: Hasselblad 553 ELX **Film:** Kodak EPZ

One May, I was scheduled to go to Miami to shoot an annual report. *Ray Gun* magazine asked me to do a fashion spread while I was in town, and I proposed a club-fashion piece. Because the magazine was so radical looking, I put together a wild cast and crew of models, stylists, and hair and makeup artists. No easy feat, since most people leave the Florida heat and go up to New York that time of year.

This image was shot during that two-day fashion shoot. Since it was such an edgy publication, known for taking risks, I was never too concerned about the technical "perfection" of any of the shots

I was making for them on this shoot. I often shot using the interesting light in this particular environment, even when the shutter speeds were very low and the images might be blurry. There was this beautiful red, neon light coming from outside a tattoo shop where this mural was painted. I did not want to loose the look and feel of the environment in the shot, so I predominately lit under the red-colored neon. To make sure there was something sharp in the image and to get some white light in the shot, I placed a softbox to the far left side of the frame. The resulting image has the strobe predominately lighting the man and the neon as the main source for the woman.

Wall

Medium
Chimera softbox

Woman

Man

Red neon light source

Comet PMT strobe pack

Hasselblad 553 ELX

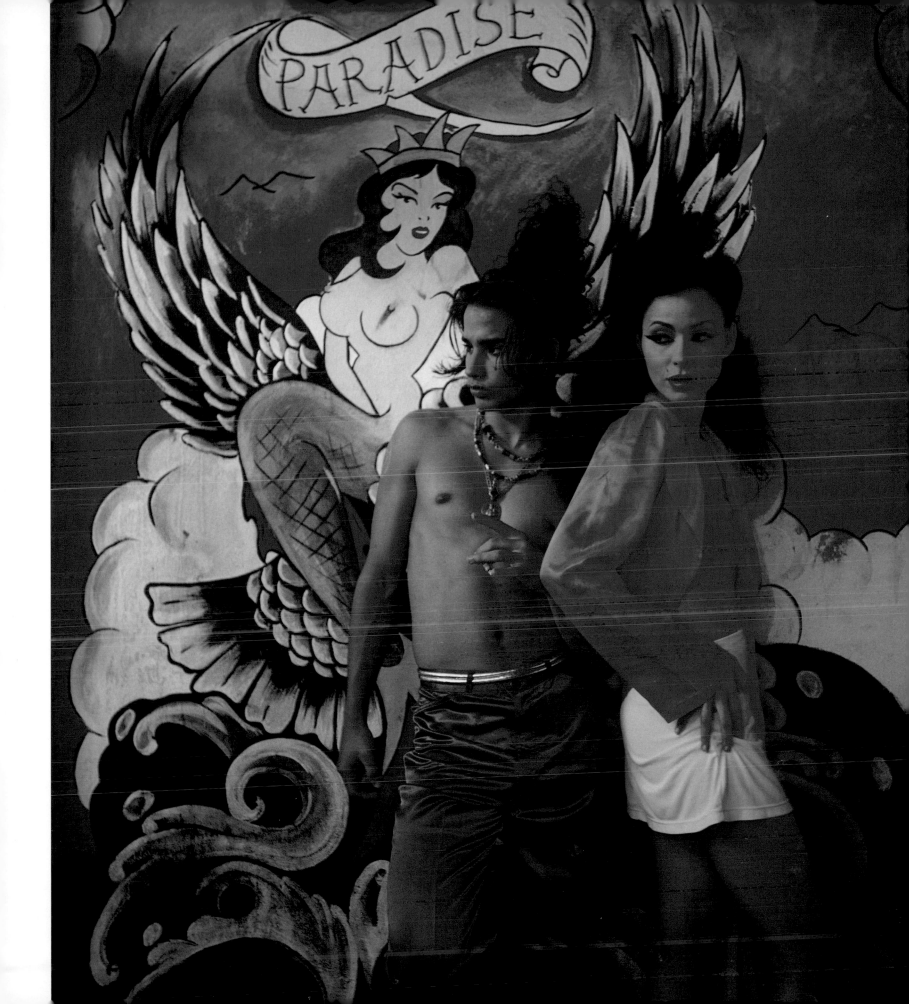

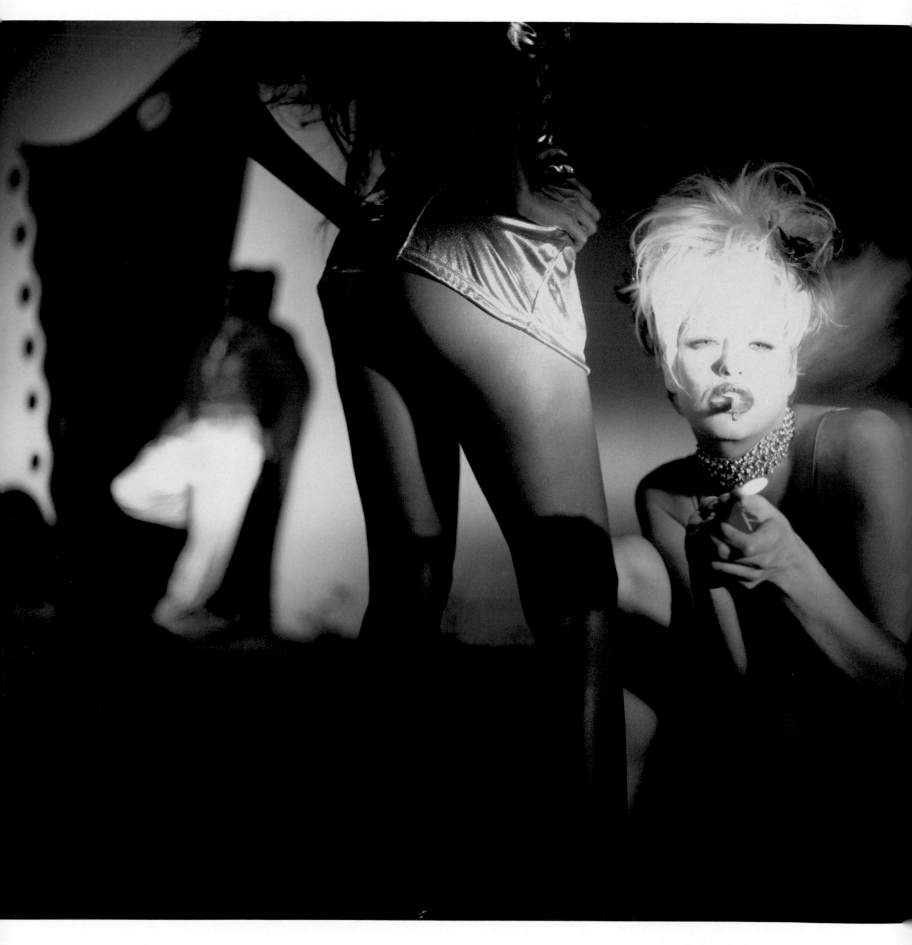

Contrast

Subject: Miami Fashion Story II **Usage:** Fashion spread, *Ray Gun* magazine

Client: David Carson, Creative Director **Lighting:** Van headlights and Comet PMT with 20° grid spot

Camera: Hasselblad 553 ELX **Film:** Kodak EPY

This is another piece from the fashion story for *Ray Gun*. I really wanted to push the boundaries here. Since the fashion shoot was about the style and decadence of the Miami night scene, and not about the particular faces of the models, I had a lot of freedom to do what I wanted. I had always liked the Rene Magritte painting *The Pleasure Principle*, in which the head of the subject glows like a light bulb. I achieved that here by putting the model very close to the headlight of the production van so that she was many stops hotter than the rest of the shot. By putting the main subject so close to the light source, it made the exposure ratio dramatically different; the subject near the light was three stops brighter than the camera's f-stop, which was set for the correct exposure of the model in the middle.

The guy in the background was strobed separately, because there was no existing light in that part of the alley.

Since I work so much, I usually do my experimenting on assignment (I have little time to regularly test), and this was the perfect shoot for experimenting. I shot the Kodak high speed 400/800/1600 slide film at the time, and just generally broke more lighting rules than I usually do. In the case of the photo In the alley I used the car headlights to light the women, and one battery-operated Comet PMT to light the club kid in the background. I purposely put the woman in front very close to the car light to let her face "burn-up"; as I said, it was a least three stops lighter than the overall picture.

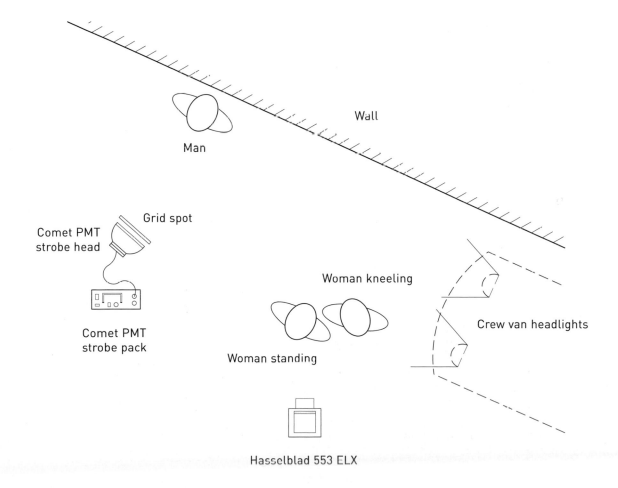

Wall

Man

Grid spot

Comet PMT
strobe head

Comet PMT
strobe pack

Woman kneeling

Woman standing

Crew van headlights

Hasselblad 553 ELX

Softness: Hard Light

Subject: Kate Winslet **Usage:** Cover story for *USA Weekend*

Client: David Baratz, Director of Photography **Lighting:** Dyna-Lite 2040 head with grid spot

Camera: Canon EOS 1-N **Film:** Kodak TX

This was a cover for *USA Weekend*. I had already taken many shots of Kate using soft light from a softbox. As I was photographing her, I noticed that she had amazing skin. So, to do something different, I had the assistants set up up a grid spot with a very thin piece of diffusion over it (a half-Hampshire frost), to just take out a little bit of the harshness. The grid enabled the light to fall off dramatically around her. The thing you notice, which I like, is the hard nose shadow that a hard light creates. It also adds dimension to her face and a specular quality and depth to her stunning eyes. Soft light is often great when someone does not have great skin, but in this case, the edginess of the hard light brings a nice drama to a beauty shot.

Seamless paper

Kate

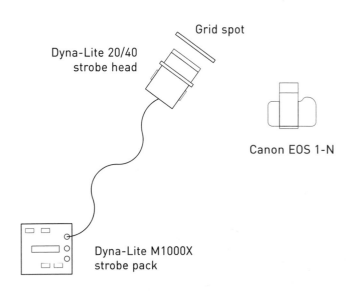

Grid spot

Dyna-Lite 20/40 strobe head

Canon EOS 1-N

Dyna-Lite M1000X strobe pack

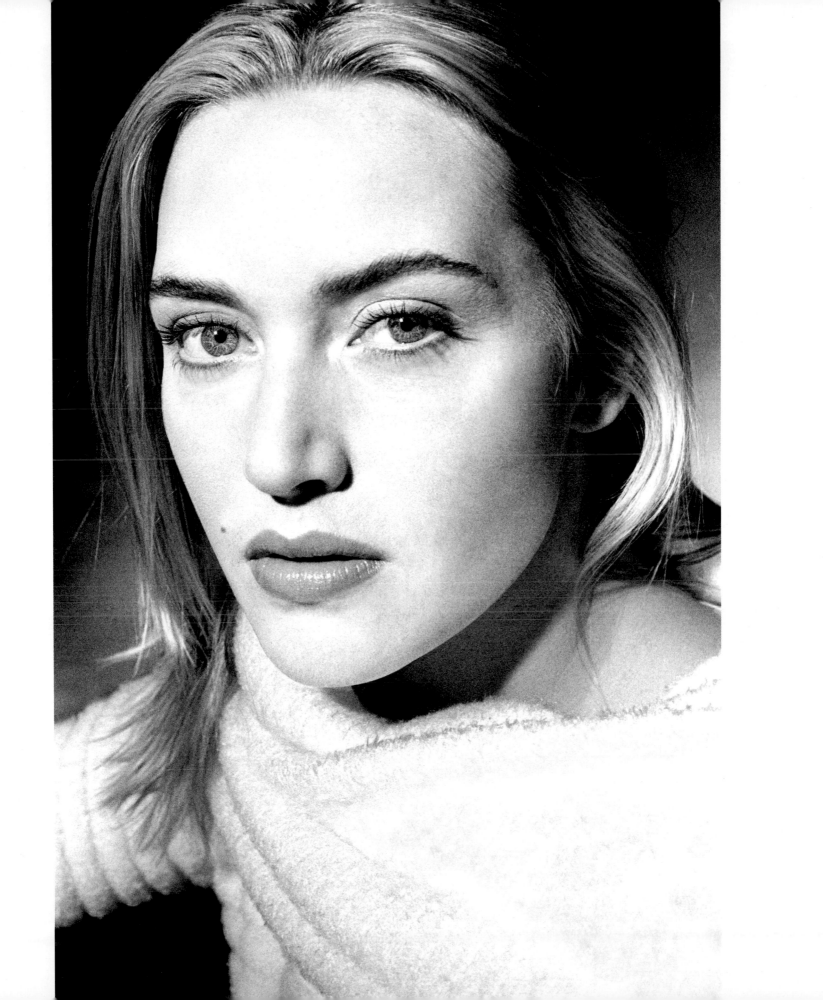

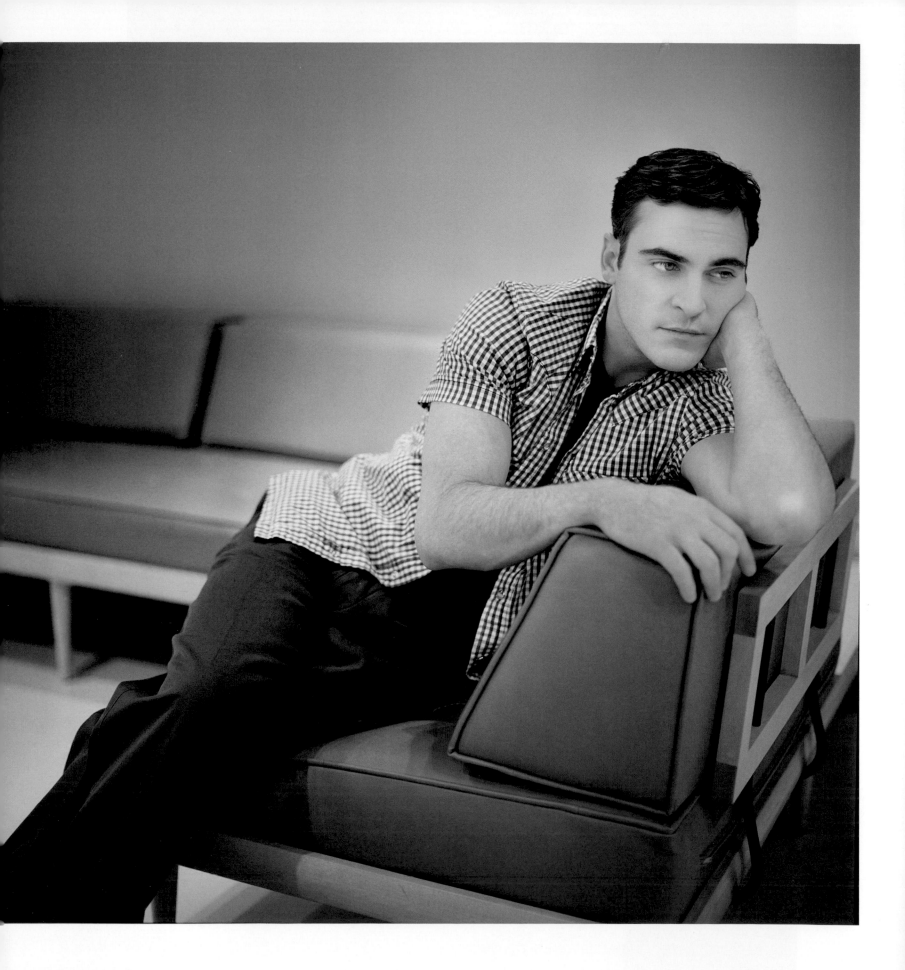

Subject: Joaquin Phoenix **Usage:** Cover of *USA Weekend*
Client: David Baratz, Director of Photography **Lighting:** Soft light and natural light
Camera: Hasselblad 553 ELX **Film:** Kodak 160VC

This is a very simple image where I wanted to keep the look and feel of the room's tone and color and still light Joaquin's face well. The room was already softly lit by natural daylight through the window; any added light had to be contained and at a minimal power so it did not overpower and change that natural light. This

was a perfect situation for a gridded soft box. When brought close to his face, the low-power, soft light fell off naturally and lit only his face. The gridded light blended with the natural light in the room without overpowering it.

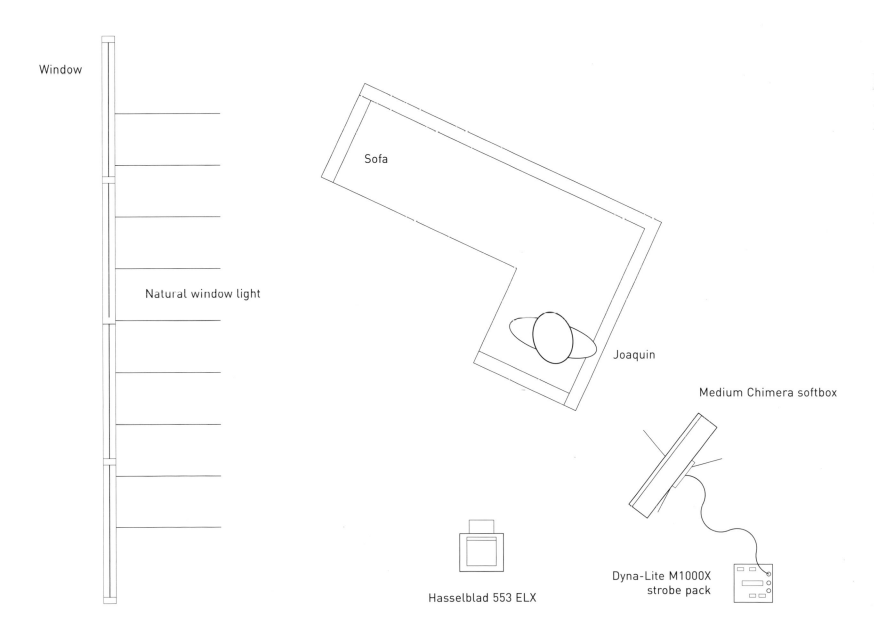

Window

Natural window light

Sofa

Joaquin

Medium Chimera softbox

Hasselblad 553 ELX

Dyna-Lite M1000X
strobe pack

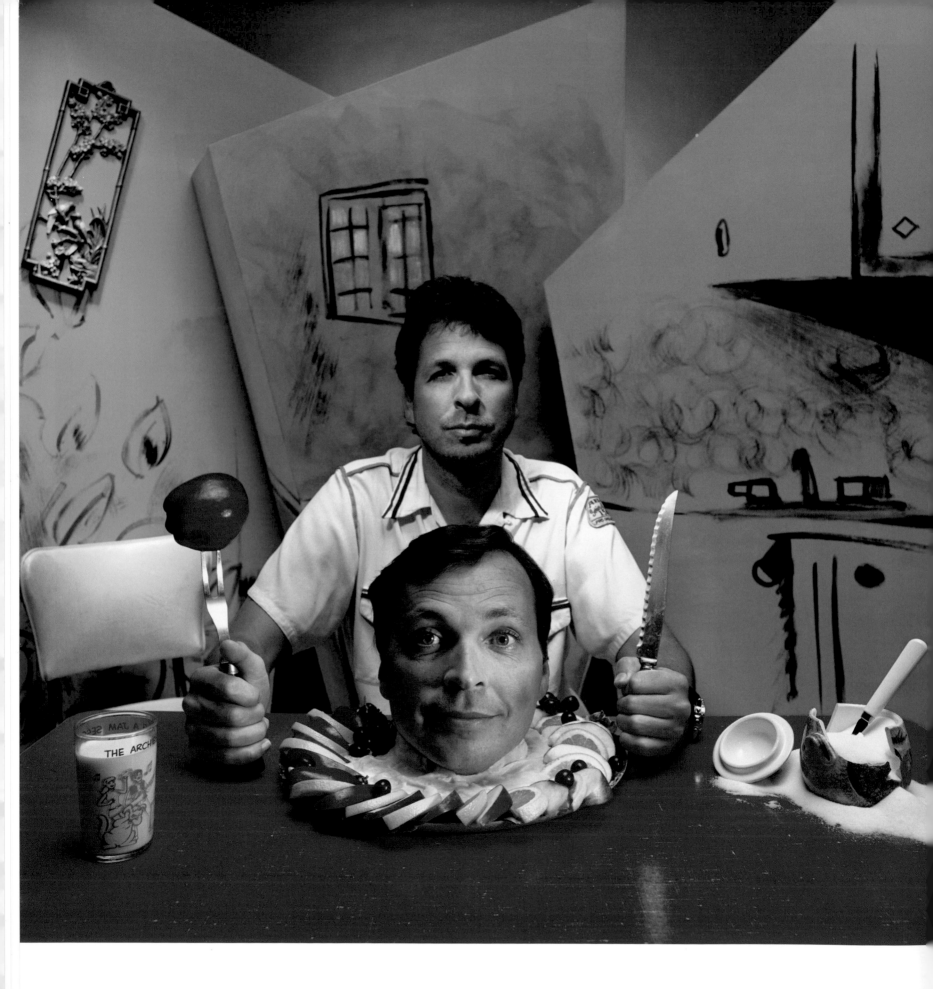

Specialty Lights

Subject: The Farrelly Brothers **Usage:** Feature story for *Entertainment Weekly*

Client: Michael Kochman, Photography Editor **Lighting:** Dyna-Lite heads with grid spots

Camera: Hasselblad 553 ELX **Film:** Kodak E100S

This shot was done with many individual strobe heads, all of which had grid spots on them. (I love grid spots because you can easily focus little pools of light where ever you would like.) The idea was to have sort of a colorful *Cabinet of Doctor Caligari* look. I used a large softbox from high above as an over-all fill light, but everything else was lit with the accent of a grid: Peter (whose head is on the plate) with a 10° grid from

camera right, Bobby with a 3° grid, the wall on the left with a 10° spot, and the blue background with a 40° grid from behind the set wall. By using grids over the strobe heads, I was able to place light where I needed it without having to over-light the entire set. This enabled me to keep the colors saturated and achieve the "pop art" look I wanted.

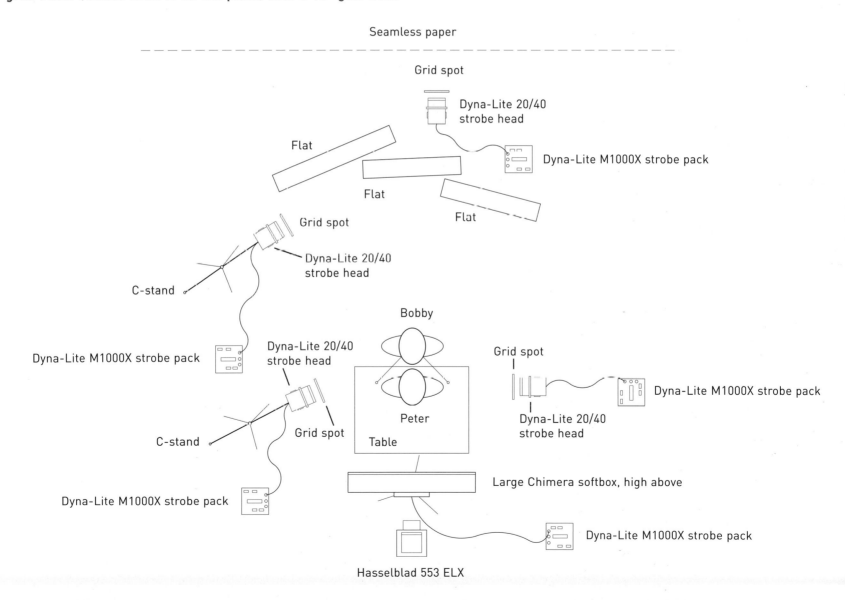

Shadows

By using the lights and lighting tools you can not only manipulate and control light, you can also create and control shadow (the absence of light). In my images, I like to have a balance between the areas of the image that are lit and the areas that are not. I control where the light hits or doesn't hit by using "tight" light sources like grids, optical spots, or Fresnels. I use the lit and unlit areas to create contrast in the scene and I expose for the shadow. The natural instinct for the lighting novice is to light everything evenly in order to expose the film "correctly." The thought is: if you expose the film at f/8 everything should be at f/8. But that, to me, is a very flat way to light a scene. Creating both lit and unlit areas (contrast) is a very dramatic way to light and, for me, drama makes a better image. I paint with light.

Another way to create the light and dark areas in a shot is to place an object between the light source and the subject that partially blocks the light rays emitted by the light source. I have used everything from an actor's stand-in, to an office plant to create shadows this way. I also use flags, gobos, barndoors, and cookies as part of my standard equipment on every shoot. You can use anything to create a shadow, but keep in mind that the softer the light source is, the harder it is to see and control the shadow.

The quality of the shadow is also an important consideration. I often use what are known as open-ended nets and flags to gently "feather" light off of objects in the shot. The subtle shadows that open-ended nets and flags produce can be controlled by moving the net or flag closer to the light source for softer shadow or further away from the light source for sharper shadows.

When you learn to control the shape and quality of shadow, you can create any mood or environment you want. I had an assignment from *Time* to shoot a kid who was a world champion video game player, and I wanted to create shadows of the game's characters on the set behind the kid. A set builder created silhouettes of all the game's characters from heavy matte board and put them on wire to make them easier to move around and control. I lit the shot with hard and sharp focusable lights and placed the cardboard characters far enough away from the light sources to flood out the light and create sharp shadows so you could identify each character from the shape of its shadow. A few years later, I did a portrait of Bill Mechanic, Fox Filmed Entertainment Chairman and CEO. I wanted to create some atmosphere and realized that these video game characters could create the effect I was looking for. This time, instead of making the shadows sharp and literal, I moved the silhouettes close to the lights and spotted the lights out, which morphed the shapes so they were soft and abstract, giving a soft, general texture to the walls.

Strobes

While all light sources illuminate the subject, the strobe both illuminates and "freezes" the subject. M.I.T. professor Harold Edgerton invented the strobe in 1931 as a way of capturing and freezing a subject's motion while retaining sharp focus. Strobe emits intense, bright light at a fraction-of-a-second speed so you can capture your shot with a very short exposure, an invaluable tool for shooting portraits. Because you don't need a long exposure, the subject does not have to sit still, even if you're not using a tripod. A strobe, like most other light sources, can be adapted, manipulated, and controlled in various ways, using the same principles and techniques you use to manipulate other light sources.

Strobe lights come in many basic packages, from the built-in versions in 35mm and digital cameras to the professional types (such as Dyna-Lite) that use a separate head and a powerpack that houses the controls, capacitor, and power supply. You connect the head to the powerpack with a head cable. You can add extension cables to the head cable to increase the distance from the pack to the head, but I find that you lose power that way. I use the pack like a sandbag at the bottom of the light stand and then use enough extension cords between the pack and the AC power source to get the light where I want it. I always use heavy-duty 10- or 12-gauge extension cords so that recycle times are not slowed down. The packs sync to the camera via wire or a radio remote control device. The radios work well because they can trigger packs from great distances and you don't have to worry about as many wires to trip over.

Another reason strobe is great for portraits is that it allows you to overpower the sun easily. The strobe fires faster than the shutter, and works independently from it. This allows you to use the shutter to control the ambient light around you while the power of the strobe and your f-stops control the exposure on your subject. You can make the shutter faster, which decreases the ambient exposure of the background, while you increase the power of the strobe and make the aperture smaller to control depth of field. You can now be shooting at f/16 at a 500th of a second easily. Be careful, though, that the flash duration is not longer than the shutter speed you are using. If it is, the shutter will actually clip off some of the exposure of the strobe and reduce your exposure.

The beauty of using strobe is that you have control over the environment. I routinely use my shutter speeds to control the light sources in an environment and use the power of the flash units and my f-stops to blend light, adding it where I need to.

Because it is hard to see in the strobe light, it is imperative to preview or Polaroid the image before capturing it. If you are shooting with a digital camera, don't use the LCD on the back of the camera to make technical and/or aesthetic judgments—the screen is too small and the color is not accurate. Use a color-calibrated laptop screen with a hood or a calibrated computer monitor. (CRT monitors are always more accurate then LCDs.)

High-Speed Strobe

The ability to "stop" action is relative to the duration of the flash and the amount of movement produced by the subject. There are cases where basic strobe does not effectively make sharp images, like when you are covering live sports. To do that, you need a lot of strobe power.

You would think that if you had more strobe power, you would override any available light and the images would be sharper and frozen. But in actual fact, as you turn up the strobe to overpower the ambient light, you simultaneously increase the flash duration and therefore the time the shutter is open, often to the point where you can't catch the motion in focus. I've found that I can compensate for this problem by turning down the strobe power to half- or to quarter-power. But now you have the added problem of needing more light. Manufacturers have helped solve this by making a strobe pack that has an inherently fast flash duration—the Dyna-Lite 2000-watt packs.

As with any strobe, be careful that your flash duration is not longer than your shutter is open. (A flash duration in relation to the shutter can change the exposure of the flash when intuitively one should not effect the other.) This is particularly an issue with the new high-tech cameras like the Hasselblad H-1 with a 1/800th-of-a-second leaf shutter.

Shadow

Subject: Shadow Boxing **Usage:** Double page feature spread in *Men's Health*
Client: *Men's Health* **Lighting:** Dyna-Lite 2040 heads with 20° and 40° grid spots
Camera: Fuji GX 680 GXIII **Film:** Kodak EPZ

This was shot for an exercise piece for *Men's Health*. We followed a boxer through his workout routine, which included shadow boxing. Because the theme and title were "shadow boxing," I wanted the shot to involve a strong shadow, for its obvious storytelling ability. The shadow of the model became the focus of the image and the most important aspect of the shot. To get what I wanted on the wall, I used a wide grid spot so I could focus the hot spot where I wanted, but also so the corners (where the fall-off is) would fall dark, as if they were burned down. Now that I had a great shadow, I needed to see the strong musculature of the model. I took a tighter grid spot (20°) and hit just the model with it, from the other side. By using a tighter grid on the model, I ensured that the second light did not wash out the strong shadow of the first grid spot. I then gelled the lights with opposite colors in order to increase the depth and the contrast of the shot.

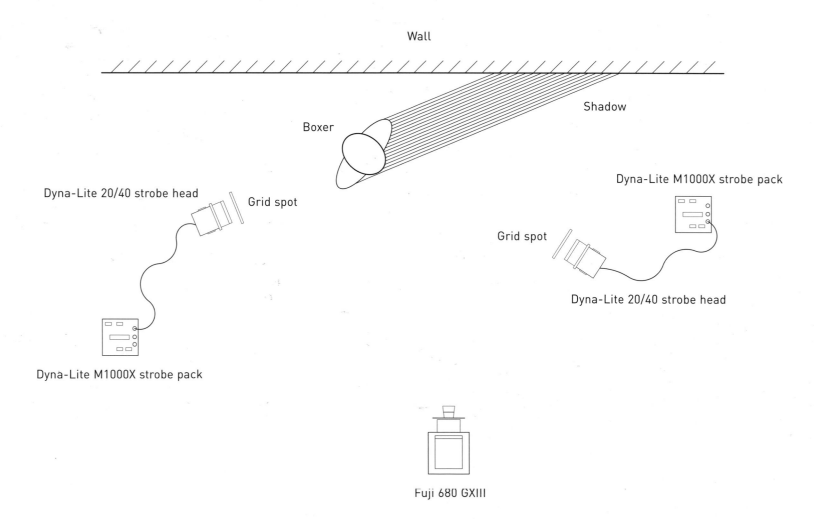

Wall

Shadow

Boxer

Dyna-Lite 20/40 strobe head

Grid spot

Dyna-Lite M1000X strobe pack

Dyna-Lite M1000X strobe pack

Grid spot

Dyna-Lite 20/40 strobe head

Fuji 680 GXIII

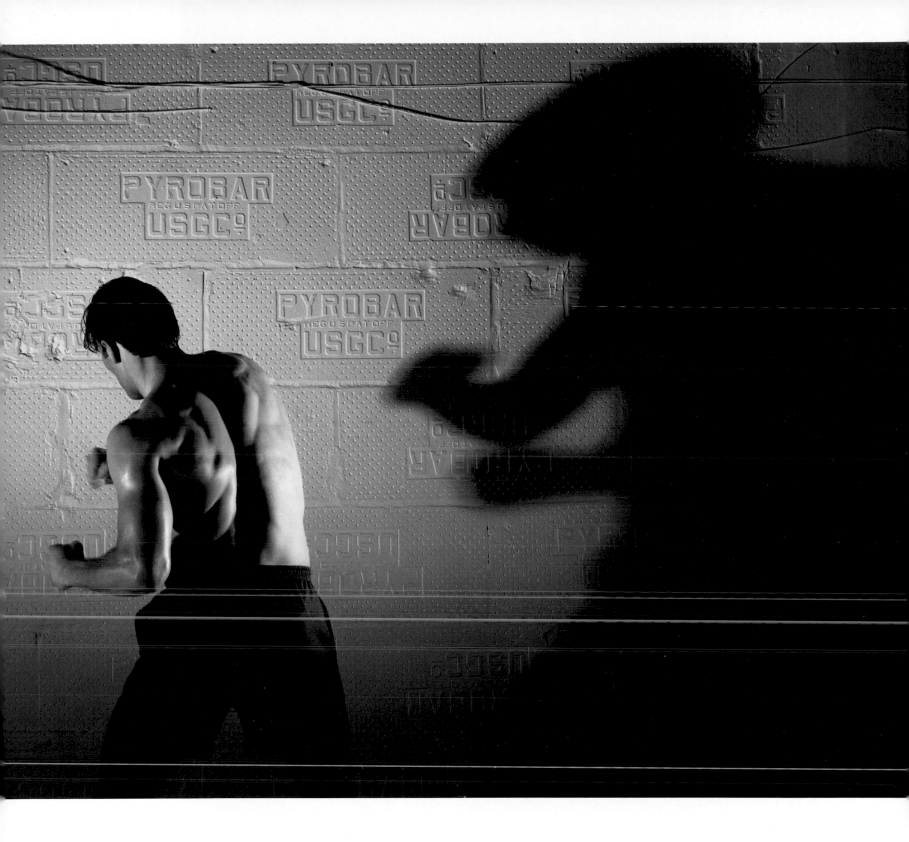

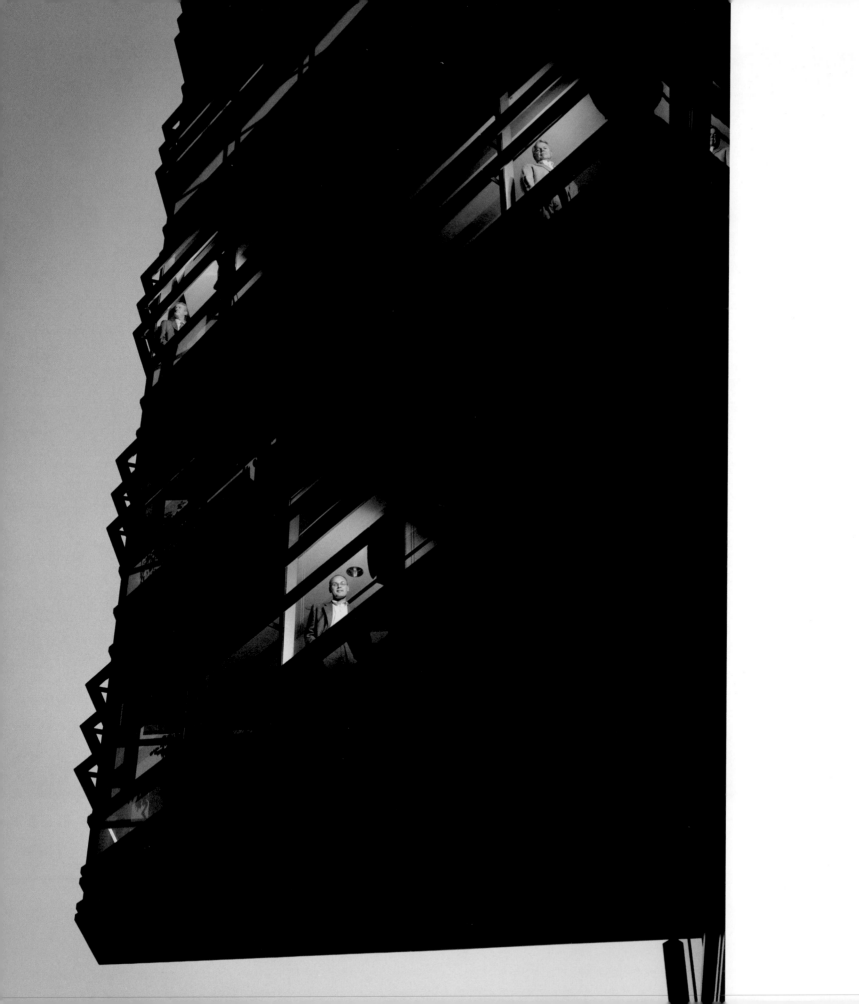

Strobes

Subject: Arden Realty Exectuives **Usage:** *The Arden Realty Annual Report*

Client: Hamagami, Carroll & Assoc. **Lighting:** Three bare Dyna-Lite 2040 heads

Camera: Fuji GX 680 GXIII **Film:** Kodak TXP

In this image, the effective use of radio slave devices and strobes created a dramatic portrait of three commercial real estate executives for their annual report. Three separate packs were used on each floor with a separate radio slave trigger plugged into the powerpacks. The power of the strobes were set high enough to overpower the ambient exposure making the building and the sky darker and more dramatic.

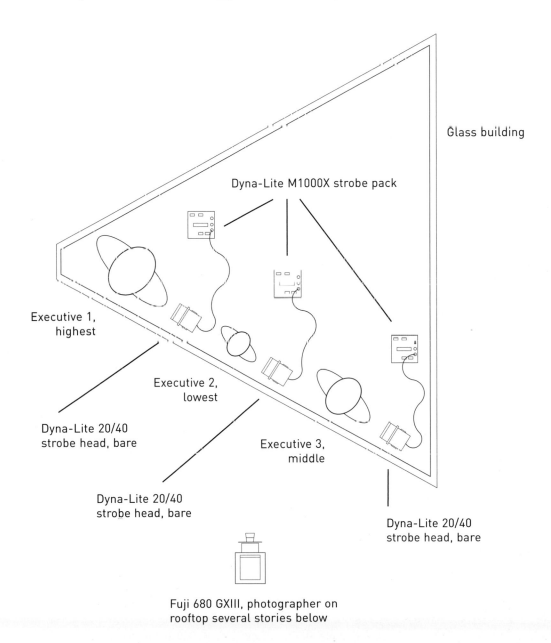

Glass building

Dyna-Lite M1000X strobe pack

Executive 1, highest

Executive 2, lowest

Dyna-Lite 20/40 strobe head, bare

Executive 3, middle

Dyna-Lite 20/40 strobe head, bare

Dyna-Lite 20/40 strobe head, bare

Fuji 680 GXIII, photographer on rooftop several stories below

High-Speed Strobes

Subject: Jet Li **Usage:** *People* magazine's *Most Beautiful People* (special edition)
Client: Maddy Miller, Photography Editor **Lighting:** Large Chimera softbox
Camera: Fuji GX 680 GXIII **Film:** Kodak E100S

This image of Jet Li was shot for a special beauty issue of *People*. I'd had many conversations with my picture editor and was well prepared for the shoot. Since the location was outside in bright daylight, I used a softbox to give him the freedom to jump around. I placed the softbox high, and did not use a fill light, so that the light would be as dramatic as is possible with a softbox. To do this and still have a fast shutter speed, we got four Dyna-Lite 2000-watt packs and two bi-tube heads. I also rented a softbox ring that held two heads in one softbox. This way I could run the four Dyna-Lite 2000 packs at half power, knowing that that would give me a flash duration 1/3300 of a second—which would be sufficient to freeze Jet Li in mid-air.

On a side note, being the Boy Scout that I am, I brought a fog machine for atmosphere, a wind machine to have his shirt fall in the perfect place, and a small trampoline to make the jumps bigger. As I explained my ideas to Jet Li through a translator, the translator looked at me kind of funny as he told Jet Li what I'd said. Jet Li responded, and the translator turned to me and said, "Jet Li does not need a trampoline!" I said, "No, but really, he has to jump very high, has to do it many times, and has to look fresh and handsome every time he does it." More translation to Jet Li transpires, and again, the translator turns to me and says, "Jet Li does not need a trampoline." We go through this a third time, before I believe them enough to start shooting. JET LI DOES NOT NEED A TRAMPOLINE. Trust me on that!

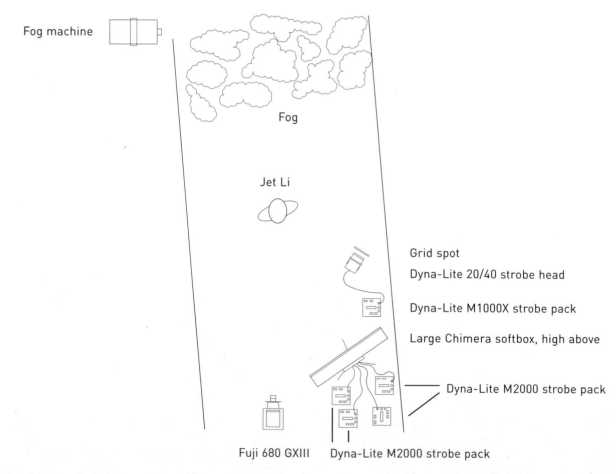

Fog machine

Fog

Jet Li

Grid spot
Dyna-Lite 20/40 strobe head

Dyna-Lite M1000X strobe pack

Large Chimera softbox, high above

Dyna-Lite M2000 strobe pack

Fuji 680 GXIII Dyna-Lite M2000 strobe pack

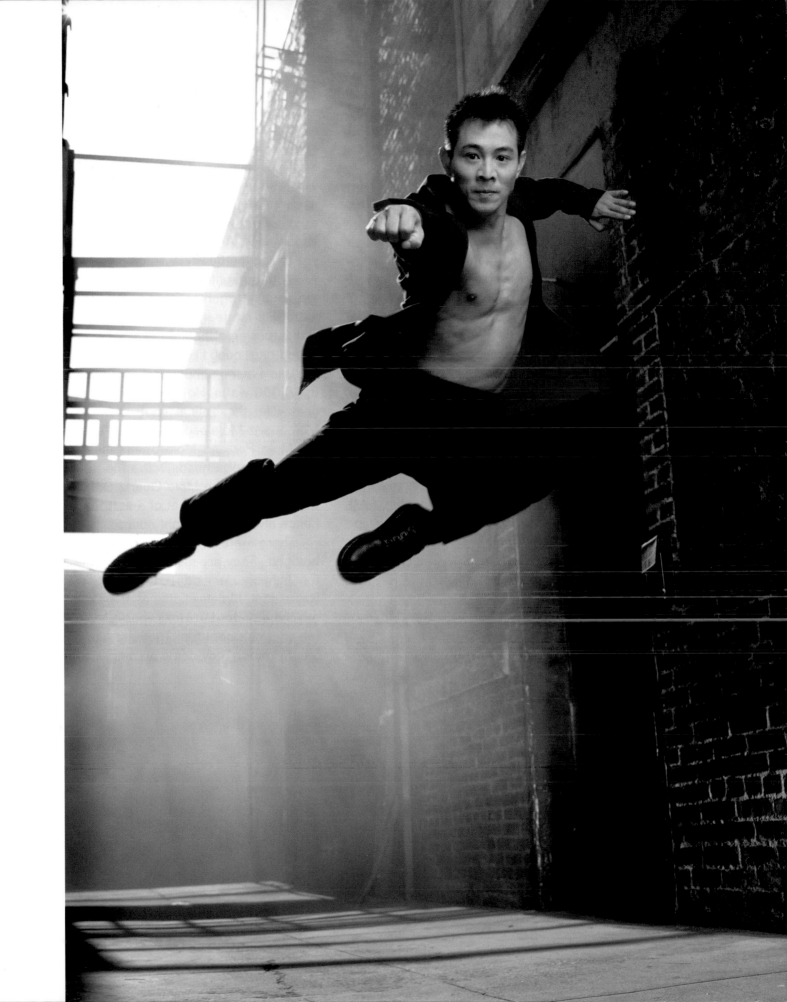

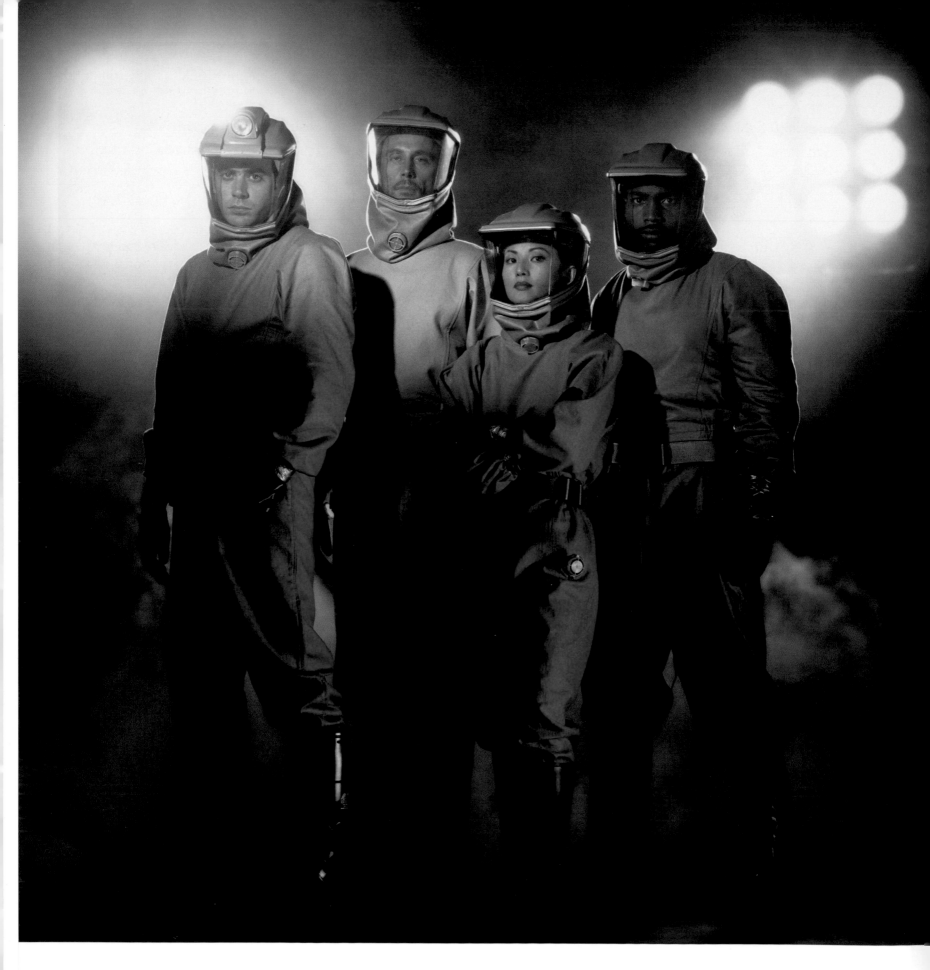

Tungsten Hotlights (9 Lights) and Fresnel

Subject: *The Burning Zone* **Usage:** Advertising shoot for Paramount Television

Client: Jennifer Weingroff, VP of Media Relations **Lighting:** 9 lights (hotlights) and Fresnel strobe

Camera: Hasselblad 553 ELX **Film:** Kodak E100S

This was a shot for a sci-fi television show that Paramount Pictures was doing. I used "9 lights" (hotlights) as part of the props in the shot to help create the look and feel of a sci-fi thriller. To make the lights glow, we brought in a fog machine; when fog is lit from behind, it lights up. To make sure the shot was sharp, even though we were shooting at slow shutter speeds for the hotlights, I lit the actors with a custom-made Fresnel strobe I own. The Fresnel light was "cut" with a barndoor and a flag so that the lower half of their bodies would fall dark. To give one more added dimension to the image, the actors were then crosslit with a gridded head with blue gel on it. The grid kept the light from spilling everywhere in the image, focusing it on the actors.

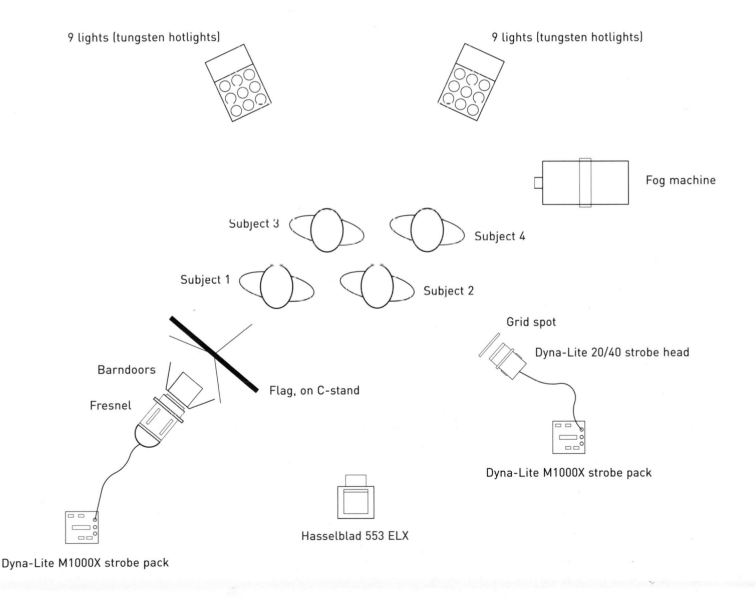

9 lights (tungsten hotlights)

9 lights (tungsten hotlights)

Fog machine

Subject 3

Subject 4

Subject 1

Subject 2

Grid spot

Dyna-Lite 20/40 strobe head

Barndoors

Flag, on C-stand

Fresnel

Dyna-Lite M1000X strobe pack

Hasselblad 553 ELX

Dyna-Lite M1000X strobe pack

Ringlight

OK, this is a popular cool-looking light that was totally overused in the '90s (and in the '70s) because it was the one light that gave a single image or a photographer's career an instant look. In fact, the look was so alluring for so many, that cinematographers figured out ways to make ringlights using hot lights for use in commercials and music videos.

First developed to do close-up and medical photography, this circular flash enclosure wraps around the front of the lens like a ring. The original ringlights were small, to fit over 35mm lenses, but they are now being made by all manufactures of professional strobes to be used with medium- and large-format cameras.

The ringlight slides around the lens so it's just out of sight. Because it wraps all the way around and is so close to the point of view of the camera, it makes a subtle shadow all around a subject. When the subject is placed near a wall or background, the shadow outlines their body, creating a surreal look. Because the ring is a small surface and much of that surface lights the subject from below, the image can appear harsh and unflattering. Therefore, I like to use a ringlight as a fill after I create the modeling on the face, using some sort of tight grid spot or gridded softbox. Because the light comes from the perspective of the camera and spreads out, it lights everything the camera sees. By using a grid spot, or any other key light source, I can expose the key at about half a stop brighter, making the ringlight half a stop darker, preventing it from blowing out the foreground. A tight grid light on the subject allows me to bring down the exposure of the ringlight so that it does not blow everything out. The under lighting is also downplayed because the other light is creating the main exposure.

Octabank

Octabank is in the cool category because it's so easy to use. It's essentially a very large softbox in the shape of an octagon. Because they are usually so big, the light is *almost* foolproof to use. Several octabanks combined can achieve an almost shadowless environment. They also make good fill lights because the shadows from the bank don't compete with any shadows you are trying to create.

Parabolic Umbrellas

This is a relatively new creation that can be used with a daylight HMI tube or a strobe. It's essentially an umbrella with a piece of diffusion over it. Broncolor currently manufactures Para PF Umbrellas, and Briese makes the Focus Umbrellas. The cool thing about parabolic umbrellas is that they're engineered to be focusable. They can go from spot light to flood light quickly and easily, just by moving the light source closer to the umbrella or closer to the diffusion panel. The shiny silver surface inside is also so efficient that you lose very little light doing so. It's great for beauty work because the light produces very little shadow and let's you control how hard the light is, depending on how heavy the diffusion is on the front. (But note that if you diffuse this light too much, you lose some of the ability to focus it.) A parabolic umbrella works much like a Fresnel, but it has a much larger surface, and it's more portable. The light rolls up and travels with you. It's a must-rent, though; buying one will set you back several thousand dollars.

Lighting It!

Okay, now that you've got the basics on lights and lighting techniques, here's as much as I can give on how I like to light and not write *War and Peace*. I light from feel. I developed my sense of lighting by looking at Polaroids and making gut aesthetic decisions. Over time, I came up with a repertoire of lighting options and combinations that I like, but I try, to this day, not to shoot anything in a formulaic manner, even if the formula was developed by me.

I approach each situation individually and figure out how to light it based on the circumstances of the day. I find standard, classic wedding and portrait photography very formulaic and slick. It has an air of cheesy commercialism to me because it's all done with the same safe lighting almost every time. I personally try to break all the "classic" rules of commercial portrait lighting. But you might first want to know what they are.

The "Classic" Rules of Portrait Lighting

Most photography lighting is based on the way light works in nature. You set up a key light (like the sun) and a fill light (like the light that bounces around from the sun and creates shadows). Standard, commercial portrait lighting places the key light at a 45° angle, to the side of, and higher than, the subject, but not so high as to make shadows in the eyes. It is then filled by another light, close to camera, on the other side. The fill is classically one stop below the key, making a 3/1 key-to-fill-light ratio, or contrast ratio—the fill adds one unit of exposure to the key side of the face making the key three times stronger than the fill. Because the fill side of the face is darker than the key side, conventional wisdom then puts a hairlight, or backlight, on the darker side of the face, one stop brighter than the key. In most cases when I see this kind of lighting, I get a hairball in my throat, not only because of how predictable it is, but because of what it generally represents: slick, pedestrian lighting that is, to me, schlocky!

Breaking the Rules

I try to do whatever I can, on a regular basis, to break these classic rules of portrait lighting, whether I use a stronger key-to-fill-light ratio, place the fill light on the key side of the face so that there is a well-defined shadow on one side, place my back light on the hot side of the face, or even put my backlight on the ground. I always try to make my lighting depart from the norm.

When I shoot outside with the sun, I often find the need to fill in the harsh shadows the sun makes. One way I do this is to first soften the sunlight by using a silk overhead or a scrim to decrease the sun's power and diffuse the point-light-source nature of the sun. I will add a light to either fill the scene or overpower the sun. If that light is added to the opposite side of the face than the sun is hitting, it becomes your classic key and fill situation, depending on which, the sun or the added light, is stronger. But even this often looks too flat to me. (It can also look too surreal or overly slick because there are not two suns.) I like to create dramatic shadows by placing both lights on the same side of the face, getting that small, narrow strip of shadow on one side of the face, which keeps it from looking fake and plastic.

To imitate this shadow in the studio, I often position backlight on the lit side of the face. (Classically, backlights help separate the subject from the background and are lit totally separately from the subject.) By lighting the shadow side of the background, I can add that separation without having to add the backlight. If I do use backlight, it's not to separate the subject from the background; I use it to set a psychological mood, or to create a look. I will often use two narrow strip boxes from behind to wrap around the face and envelope the subject.

The Classic Rules of Portrait Lighting

Subject: Robert Duvall **Usage:** Feature story for *Time* **Client:** Marie Tobias, Photo Editor

Lighting: Chimera softbox **Camera:** Fuji GX 680 GXIII **Film:** Kodak E100S

Since I throw all the traditional rules of lighting out the window in my portraits, I don't really have an example of a classically lit photo. But, if I'd shot Robert Duvall following standard lighting dogma, I would have used a fill light and a backlight on the subject, and used a set light to make the background brighter on the darker side of the subject. To me, all this is overkill. Instead, I shot this image with one small softbox and lit the backdrop behind Robert with a grid spot. To direct focus on just part of his face, I kept the hot side of his face and the brightest part of the background in the same lighting region. This stripped-down lighting really enhances the connection between photographer and subject.

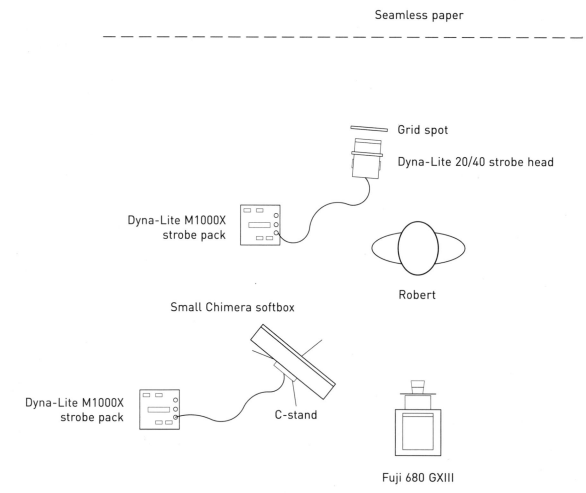

Seamless paper

Grid spot

Dyna-Lite 20/40 strobe head

Dyna-Lite M1000X strobe pack

Robert

Small Chimera softbox

Dyna-Lite M1000X strobe pack

C-stand

Fuji 680 GXIII

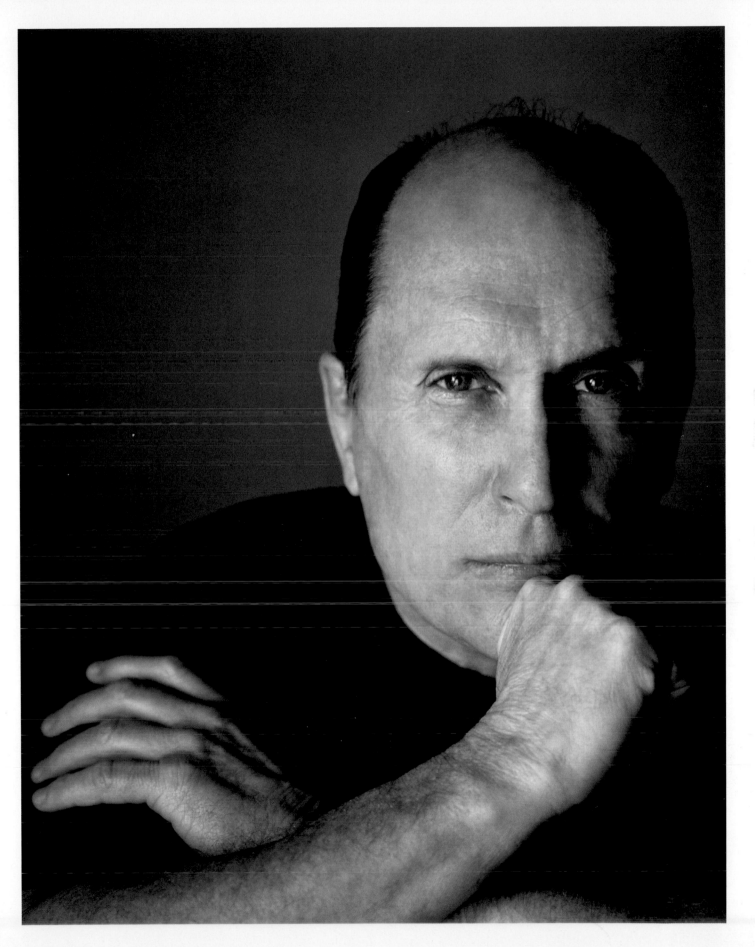

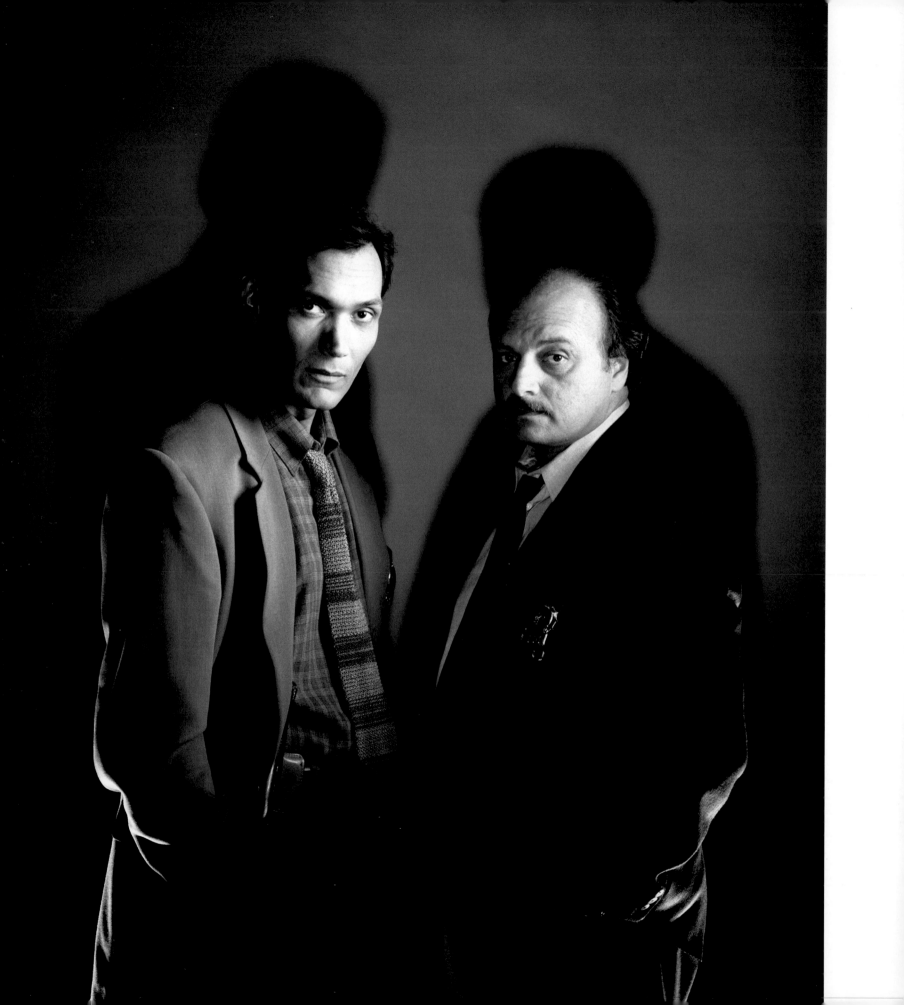

Breaking the Classic Rules of Lighting I

Subject: Jimmy Smits and Dennis Franz of *NYPD Blue* **Usage:** Cover for *Entertainment Weekly*

Client: Dorris Brautigan, Deputy Picture Editor **Lighting:** Fresnel, Soft Box and 20° Grid Spots

Camera: Fuji GX 680 GXIII **Film:** Kodak TXP

I was assigned to shoot the TV show *NYPD Blue* as a cover story for *Entertainment Weekly*. Because the show is shot in both New York City and Los Angeles, I shot the cover in Los Angeles when they were shooting on a soundstage, and then went to New York City to do location portraits and some behind-the-scenes photos.

For the cover, I rented the soundstage next to the one where they were shooting so that between takes Jimmy Smits and Dennis Franz could quickly walk over to my set. I knew they would have about an hour break and that I had to allow time for makeup and hair, yet still shoot two situations in that one hour. To get this shot I set up a gray seamless paper and placed my Fresnel strobe directly under my Fuji 680 Camera. This created

a great shadow up the seamless, resembling an old film-noir police-movie look without underlighting their faces and making a horror-picture look. Next, I cut out two small cardboard circles, taped them to a piece of wire, and placed them about a foot and a half in front of the Fresnel. The cardboard was lined up and manipulated until it blocked the light on the subjects' faces without changing the shadows on the paper. Then I lit both faces with one softbox with a grid on it. The grid kept the softbox from washing out the shadows in the background, and the softbox created a nice flattering light on their faces. Lastly, I needed to separate the subjects from the background, but, since I do not like the look of a conventional hairlight, I broke the rules a little and placed two backlights on the floor behind them, making what was essentially an under-backlight instead.

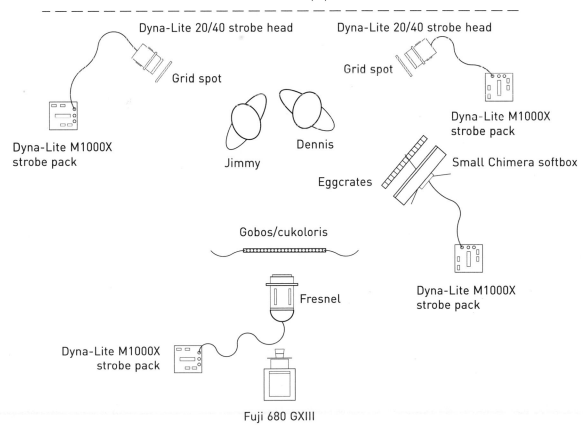

Finding Light

Finding light is the technique of not lighting an image, or lighting it minimally, and hunting around your environment for available light that works well. It is best done where you have a variety of lighting textures and filters, such as windows or openings that create beams or dappled light. This type of light changes quickly and can be lost as the sun moves or is blocked, so scouting the right location is essential. This can be a risky way to get a great shot, because it could end up being cloudy on the shoot day even if you've found the most "picturesque location" of your photographic life. However, the great thing about using found light is that, when it works, it usually does things in the image that you would not have imagined or created. It provides a level of spontaneity that can be wonderful. Use it when you see it as quickly as possible and be prepared to fill it in if necessary.

Finding Light

Subject: Marcia Gay Harden **Usage:** Feature story for *Entertainment Weekly*

Client: Mary Dunn, Director of Photography **Lighting:** Natural light

Camera: Hasselblad 503 CX **Film:** Kodak TXP

Shooting on movie sets can be difficult because your time with the actor has to fit into stolen moments between the movie takes. You often set up a shot only to have to break it down because the director suddenly needs the area in which you're shooting. (On one film set in Vancouver, I set up almost a dozen times, having to move each time before getting my shot, because the director kept changing his mind about where he was going to next.) You end up having to grab shots where and when you can, just to get something in the can. This shot of Marcia Gay Harden is one of those grabs. I had about five minutes with her on the set of a Frank Sinatra TV miniseries. We were in a highly trafficked area around the actor's trailers, so setting up light was impractical. Since the natural light that backlit everything was relatively soft, I decided to use the found light, and positioned her in front of her trailer so the light hit her face the way I wanted. The only thing I had to watch out for was that her nose not catch too much of the direct sunlight that was outlining her body so beautifully.

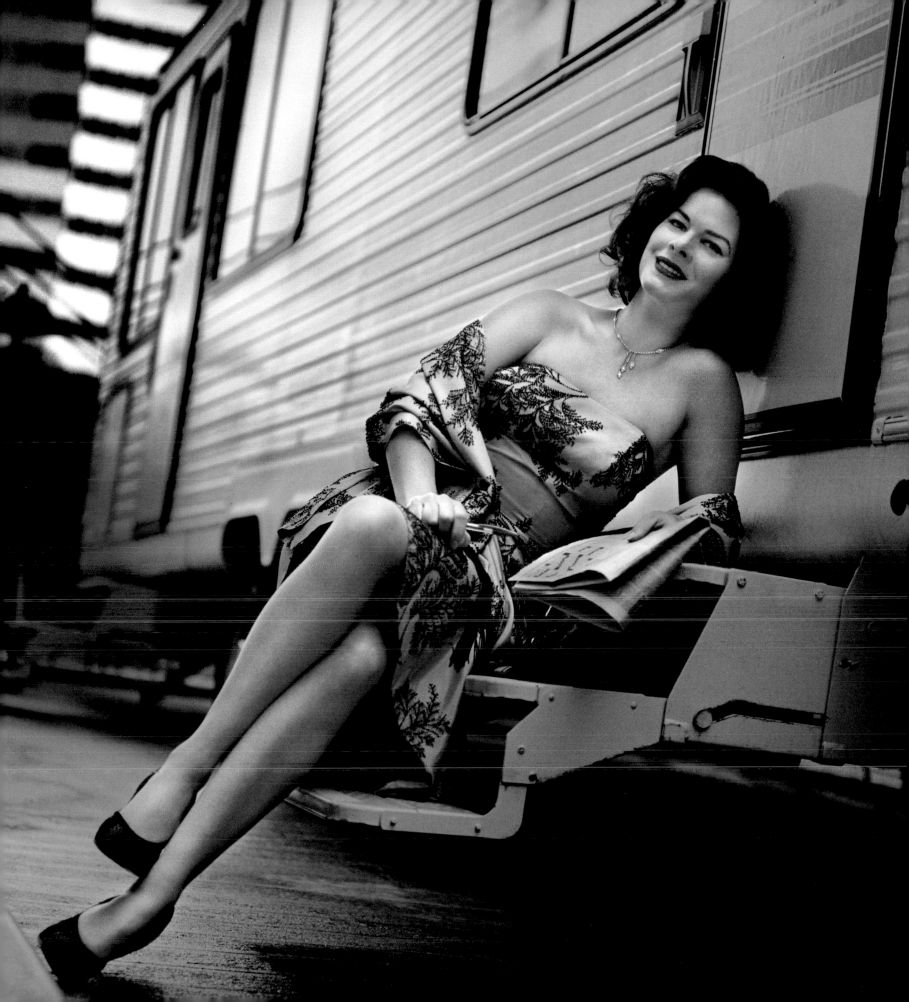

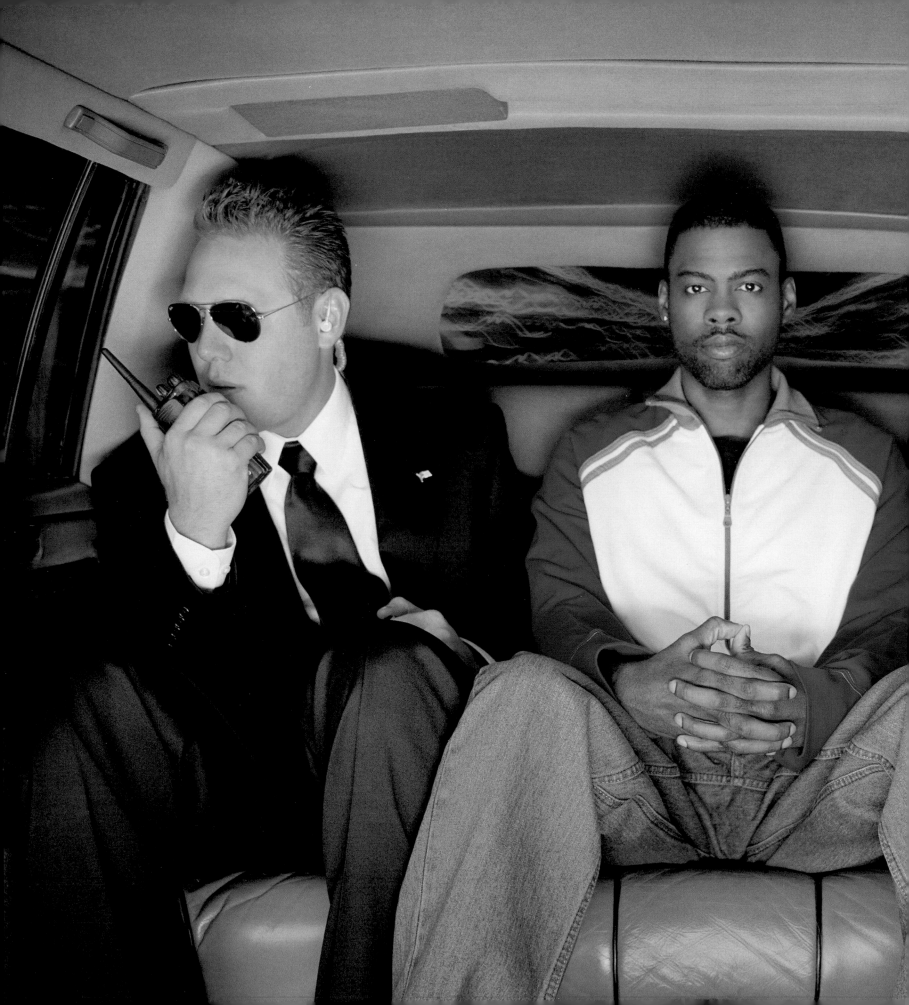

The Medium

From Analog to Digital

As I write this book, I am rapidly changing my studio over from an analog film-based business to a digital capture-based business. I'm making this change not because digital capture finally gained the capability of resolving images as well as film does, but because it finally has the ability to render skin tone well. Let's face it, as a portrait shooter, it's all about the skin tones for me. The day I didn't have to "fix" each digital image to get the skin tones the way I wanted them to be was the day I was able to shoot more portraits digitally because I no longer had to hand process each image I delivered to correct those red, patchy skin tones. Ultimately, whether you shoot digital or film, the object is to give the client what they want and to capture the image you want, the way you want it to look. If one medium helps you do that better than another, well, that's what portrait photography is all about.

Your Color Palette

Back in the film days many photographers would base their look on the film choices they made. From the beginning of my career, I developed my look with the way I used light, shadow, and subtle gels, and I kept my film choices simple. To this day, I basically use the same three types of film: Kodak Tri-X (black-and-white film), VC160 (color negative film) and E100G (color transparency film). By using the same films whenever I shoot, I get consistency and know what I am going to get every time. I can create my personal color palette in the lighting and contrast and know exactly how that will look on film. On the other hand, many photographers find their look by shooting a variety of different films in order to get different looks and feelings from the same shoot.

While the type of film you use can help establish your color palette, you must also experiment with different combinations of film stock and processing to see what combinations give you the results you want. In general, pushing film (developing longer) during processing will add contrast, whereas processing normal, or pulling it (developing for less time), will lower contrast. Transparency film will only push so far without the color shifting. But, pushing and pulling can work very effectively with negative films, because they can be manipulated in the processing and then partially color-corrected in the printing.

There are thousands of things you can do with film, including experimenting with cross-processing color negative to color slide or color slide to color negative. You can even take standard black-and-white negative and make it into a beautiful black-and-white transparency through a process called dr5, developed by dr5 Chrome of Los Angeles.

When you find a process and look that you like, you need to know how to repeat it. You want to note and absorb the techniques and settings that work, so they become intuitive and the image in your mind's eye flows straight through the camera. That's why I don't recommend you use the "shotgun method" of shooting—the one where you bracket and cover every possible option because you don't know how to get what you want. If you operate this way as a portrait shooter, you will inevitably miss the best expression, or "the moment," because that particular bracket didn't have the light, or contrast, or color you want.

This shot of director Stephen Sommers, for a special edition of *Premier* magazine about special effects, was inspired by an image that had been rattling around in my brain since a college photojournalism class: a coffin maker eating his paper-bag lunch while sitting in a casket. Stephen was directing *The Mummy* so I had the studio move the sarcophagus from the film to the editing room that was my photo set. I took the concept of the coffin-maker shot a step further by wrapping Stephen cloth strips, like a mummy. To add to the drama, I had the sarcophagus positioned so it loomed over him. I gelled both Steve and the sarcophagus, and then cross-processed the film to give the image added impact and relate it to the special effects theme of the story.

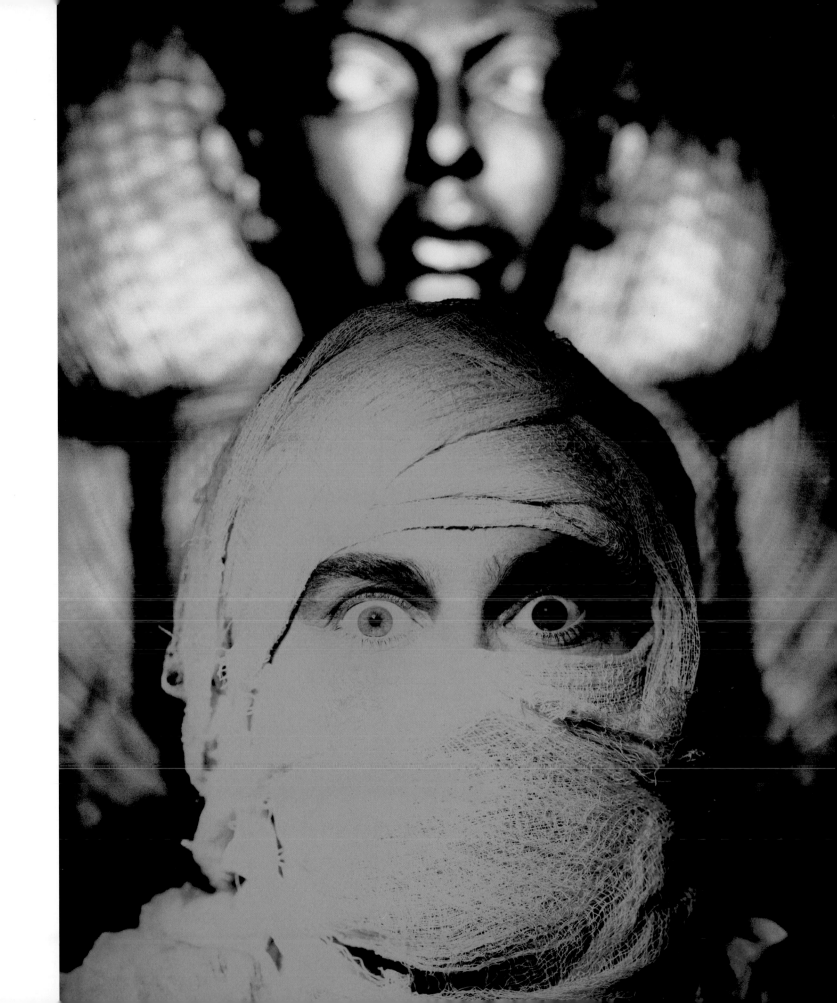

Getting the Color You Want

After all of your experimentation with different film types and processing to develop your look, you must be is able to *deliver* that look consistently. And, the way to do that is through developing good workflow procedures. I am going to go through the workflows I've developed for all the different mediums I shoot. I'm leaving digital until last and will challenge your concept of shooting digitally.

Transparency Films ⸺⸺⸺⸺⸺ ■

Transparency is the most basic of films: you expose it, process it, and what you shoot is pretty much what you get. You have some control over it in the processing, but that is basically limited to an f-stop or so in latitude. You cannot make major corrections to transparency film in processing if you screw it up in shooting; you can only push film so far before the color changes.

The difficult part of consistently exposing and lighting transparency film is that ASA/ISO is a subjective thing. ISO 100 film, exposed at 100 and processed normal, might look great when you are shooting landscapes or still life. But that same ISO 100 film shot and processed the exact same way might look terrible for a portrait. In fact, I routinely push ISO 100 film to get the look I want. I think most film is "overrated" in ISO terms, especially when it comes to doing portrait work. Transparency film almost always looks underexposed to me when it's shot and processed normal. And, because the point here is that you are trying to create your own look and color palette, getting the film the way *you* like it is critical. Good exposure, lighting, and processing can be subjective. It's that subjectivity that will help you create a style.

The Test Roll

You also need control over the final processing of your film to consistently deliver your look. I shoot a ton of Polaroid instant proofs before shooting film to get the lighting right. I use the instant proof to check the contrast, highlights, and shadow detail in the shot. But because Polaroid is not the same material as the film, it only gives you a rough idea of what you are going to get on film. Once the film is shot, manipulating the processing then creates the final look of the image. To facilitate success in the processing stage, I *always* shoot what is known as a test roll.

The idea of the test roll is that every situation—each change in lighting, camera settings, or pose—gets its own frame on the test roll. Label your test roll ("Test Roll" works well), and after you've set up your first situation, shoot one frame on the test roll before you shoot the rolls for the actual shot. (If we are moving quickly, I will sometimes shoot the test frame after the actual rolls are shot.) Note the frame number of this test shot.

Then, as you shoot rolls in that particular setup, mark each roll with the frame number it corresponds to on the test roll, and put them in a plastic bag, also marked with that number. For example, the first situation gets shot on frame one of the test roll, then, all the rolls from that situation are marked "#1" and go in a bag marked "#1." The next situation becomes "#2" on your test roll, and so on and so on. You must shoot complete rolls of each setup; don't start shooting a new situation in the middle of a roll. And each new situation gets a new test frame and completely new rolls of film. You cannot cut corners here; keep a Sharpie handy! The test roll is your essential resource for getting the results you want out of the processing lab. (You can also snip or clip test frames on your rolls of film rather than having a separate test roll, but it's often very confusing to lab personnel, and it gets very expensive, so we don't do it very often).

Polaroids make great records of the different photographic materials and how they related to each other, but they, alone, are not critical to the processing of the film. (Some photographers keep Polaroids, along with extensive log sheets that track the details of each shot, in writing. This system is very helpful when you're shooting many different types of film that have different processing instructions. I keep written logs every time I am shooting more than one type of film and trying to get different looks for all of the rolls.)

Color is very specific to any photographer, or at least should be. When shooting in color, I firmly believe in using and controlling the medium to its fullest possibilities, whether going for moody, unsaturated color, bright, well-saturated color, or anything in between. This was a shot for a *USA Weekend* cover, and they like bright colors. Since I like richer more dramatic colors, I worked on finding the right mix of saturation and mood. In this case, I did not want the colors to get muddy from being too moody; I wanted them to be rich and colorful, not pastel and colorful. (For all my color images, I go into Photoshop and put the final curve on scans or digital files so I can deliver the exact color for my taste and the client's needs.)

Digital Capture or Taking Photographs with a Digital Camera ■

With film, you work very hard to get the transparency or Polaroid to get the image the way you want it. When shooting the picture digitally, you not only have to get the look you want, you also have to get the best capture possible. But I don't allow the constraints of the capture to take me away from the creative process of the shoot.

Digital has an impact on the creative process. On the positive side, the instantaneous feedback from a digital system allows me to monitor, in real time, the progress of a shoot, both creatively and technically. And it allows the client, with possible good or bad implications, to provide immediate feedback. On the other hand, this instant feedback can push you to "move on" too quickly when everyone feels the shot's been nailed; whereas on a film shoot, the unknown often prods a photographer to shoot more and take a different approach with the chance of finding a better "hero" shot.

I use a digital capture team called Image Mechanics in Los Angeles. My goal is to light the shot the way I want and then have a digital tech from the team make sure the lighting is within the parameters of the particular digital camera I am using.

If you are shooting digital without a tech crew, I suggest you open the image up in Apple's Aperture software or in Photoshop RAW, and examine it to make sure that you have a good histogram. Look to see what areas have no detail in the blacks and if any of the skin tone has blown out in the red channel. Skin tone is the most critical, because if you have no detail in a patch of skin it will need extensive retouching. Both the Apple Aperture and Photoshop RAW software have highlight warnings that show you in bright red what area is blowing out, or has no detail. In Photoshop RAW, you even have a check box that shows you what shadow area is going totally black, with no detail. Once you know that you are capturing all the information you need you can safely shoot your image.

When shooting people in digital format, the two biggest concerns are getting the information in the correct area of the image's histogram (more towards the mid-tones than in the shadow area), while not letting the red channel (there are three channels: red, blue, and green) blow out anywhere in the face. Getting the information on the right side of the chip enables you to get less noise (grain) because noise is most prevalent where the chip has the weakest signal—in the dark areas.

I always shoot in RAW mode because it gives me the ability to color correct and get the images the way I want them in the processing afterward. A jpeg capture is 8 bits and the RAW capture of a Canon camera is 12 bits. While it might seem that four extra bits isn't much, it is actually a huge difference. 8 bits gives 256 gradations of color per channel (2 to the 8th power), and 12 bits gives 4096 gradations of color per channel (2 to the 12th power). Checking of exposure is done in Photoshop RAW processing. Shooting RAW takes up a lot of space on your chip—approximately 300 jpegs to every 100 RAW on a 1G chip. In today's digital cameras you can choose the RAW-plus-jpeg setting, using the jpeg to just quickly look at the visual content (not lighting!), but never as final media. A jpg is simply not as sharp and good looking as a tiff or a Photoshop file, and is definitely not the way to go when delivering good photography.

The last step is to look at an image from each situation and make the tonality and color adjustments on it before it is processed. This should only be done on a recently calibrated CRT monitor like a Sony Artisan or a La Cie Blue. LCD monitors cannot be used for accurate, consistent work unless you have the new Eizo LCD that has contrast control and can produce all of the colors in the Adobe RBG color spectrum. LCD monitors in general have a contrast issue; images won't look the same when you look at them on a CRT monitor, even if the LCD has been calibrated. It is important to be in color sync and use a color calibration system like the Gretag Macbeth Eye-One system. Consistency from your office, to a lab, to a client, to the printer is what will help you communicate that vision of yours all the way to the final printed page.

If you process your own digital files, it's as time consuming, or maybe even more time consuming, than it is to process and print your own film. So, many photographers take their files to the lab for processing. The lab's calibrated monitor and controlled lighting (which affects the way the image looks on the screen) allow you to see your shots accurately. Sit with the lab technician and review, then approve or correct, each shot. Otherwise, you'll end up with the lab technician's vision of how the image should look, not yours.

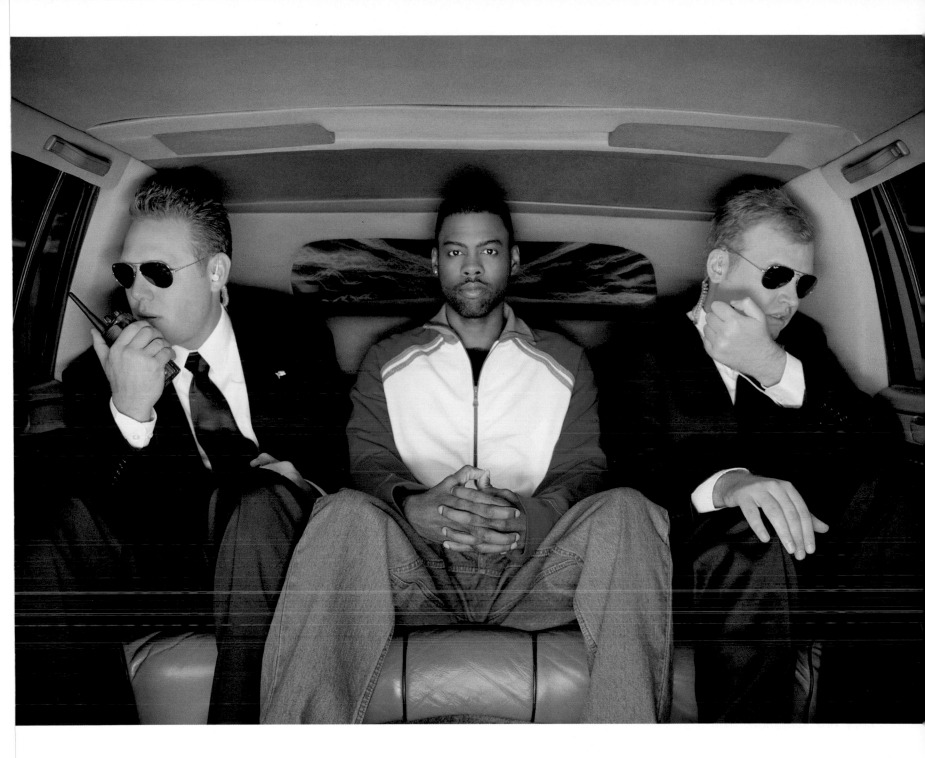

This was part of a cover story for *USA Weekend*. Chris was making the movie *Head of State*, where he played the first African American president of the United States. I thought incorporating Secret Service agents into the shot would tell that story well, particularly if I shot them all in a presidential limousine. Since shooting in a real limo presented the daunting challenge of how to squeeze all that equipment into a small, confined space, I rented a rear section of a limo that was designed to function as a set. This gave me complete freedom to position the lights where and how I needed them. To enhance the reality of the shot and give it an extra edge, I lit the entire scene from below using a horizontal, medium-strip Chimera softbox. This underlit everyone as if something inside the car (say a television) was providing the glow, but kept things from looking scary, or horror-picture like. The background in the windows was added digitally.

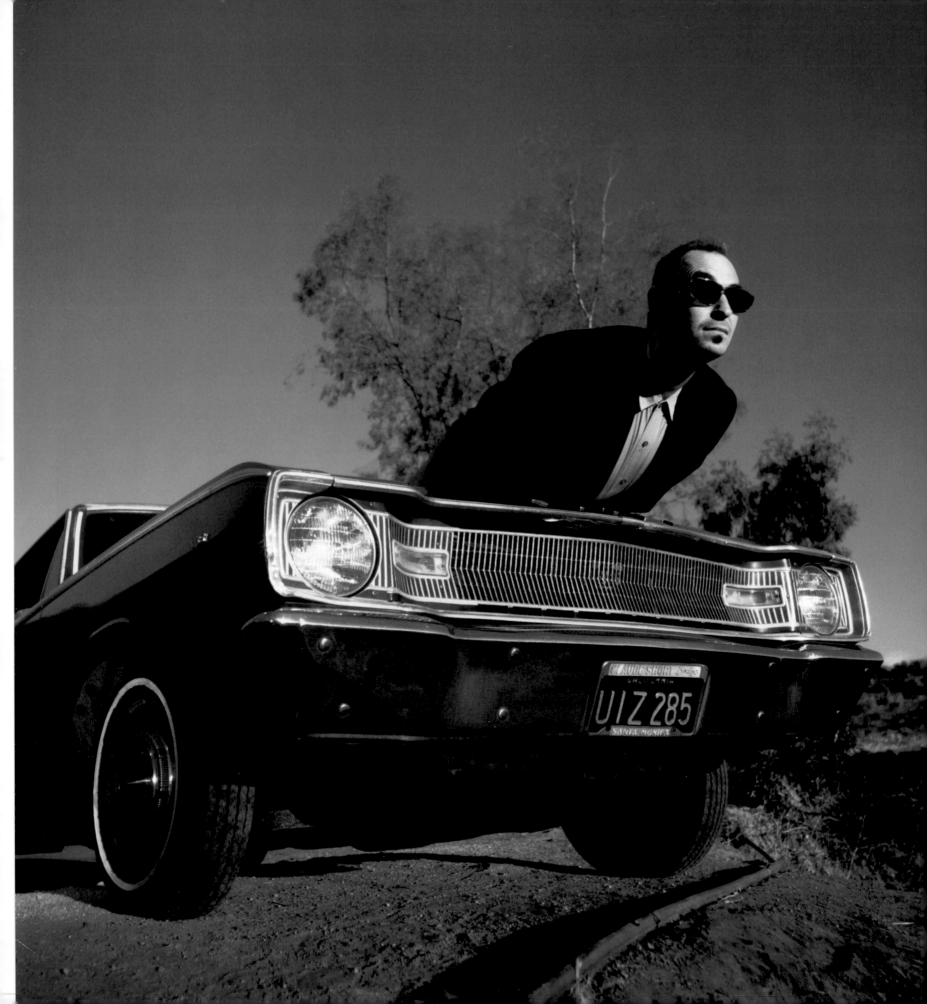

This shot, to me, symbolizes my departure from photojournalism. Up until I did this shot, I had just captured reality; this image is where I started to create my own look—the conceptual style of portraits I do today. *Buzz* magazine assigned me to illustrate a tongue-in-cheek piece by writer/director extraordinaire, Barry Yourgrau. The piece was about how phallic and cool his old, junky, beat up 1967 Dodge Dart was; he claimed it was one of the most impressive and powerful cars in Los Angeles, the car culture capital of the world. As I read Barry's piece, the word "phallic" stuck with me. I kept thinking of the power of that big, wide, silly car, and I immediately had a vision of the writer himself as a hood ornament. I had recently seen a portrait by architectural photographer Tim Street Porter of a designer's disembodied head on top of something he'd designed. I liked Porter's use of the subject as an integral part of the environmental portrait, and I used that concept in this shot.

I did most of the shoot with Barry in various poses around the car, but for the final shots, I asked him to climb up on the hood of the car and play the role of hood ornament, which visually integrated the two subjects—Barry and his car. The image was cross-processed to add mystery and the feeling that it was shot at night. The client loved it, Barry loved it, and I loved it—it was this hood ornament shot that made the pages of the magazine.

Locations

A good location can help you tell a specific story as well as drive home a general feeling or concept. Locations are powerful tools because they set the mood, or even the literal meaning, of the image. I normally use the location to set a tone or to be part of an overall concept rather than literally represent something. Having spent years as a newspaper photographer shooting "Joe the Shoemaker" in front of "Joe's Shoe Store," I got my fill of the absolutely obvious. But, however you use it, the location is an important part of successfully communicating your vision in the image.

To find a good location I will often use a location scout who knows a particular area. Their job is to go and shoot current images of the locations they recommend, and to make sure they can secure the location for the right date and within budget. (Current images at the right time of day are key so you can check the light.) Once we pick a location, the scout will often negotiate the deal and finish any paperwork or permits that are needed. If you cannot use a scout you can do it yourself, or hire a good assistant to do some of the legwork for you. Another option is to go through a location company. Whichever way you find your location, I recommend a "tech scout" (technical scout) before the shoot so you can work out all the logistics for the shoot day.

American Way assigned me to go to San Antonio, Texas to do a cover story on Dwight Yoakam, who was there filming the movie, *The Newton Boys*. He had a noon break on my shoot day, but he also needed to have some cowboy hats blocked (adjusted). So, he invited us to come along and do the shoot at the hat store, and we gladly accepted, thinking a Western hat maker might offer some interesting possibilities. After Dwight took care of his business, we started shooting him inside the store, with all the hats.

I needed an additional situation, so I took Dwight outside, grabbed my Fuji 680 camera, and lay on the ground, almost in the street, to get this shot of him standing in front of the store. My assistant set up one Comet head with a small softbox, in the street, to punch a little light on Dwight, and I shot this, hand-held, at a 400th of a second. I had to back up and use a long lens to pull in the entire atmosphere around him.

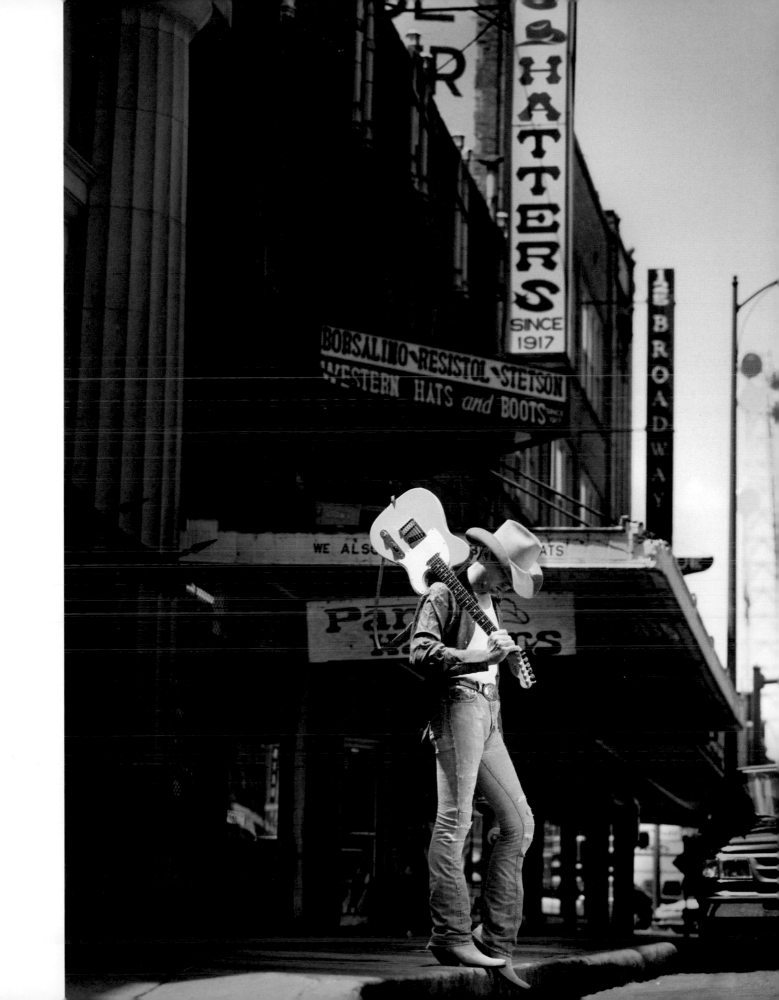

Usually I have an overall concept about the location, like this image for *Wired*. Here I had to shoot Tim Montgomery, the world's fastest man, for a cover story about "speed." For practical and logistical reasons, I needed a location that was as close as possible to where he was training. I had limited time with him and needed to use that time for shooting, not traveling. I worked out a concept with the picture editor, Brenna Britton, in advance: Tim would be dressed for speed in a futuristic, silver, track wardrobe, trailing a silver parachute, like those that explode out of speed-test cars on the salt flats. The idea was to show that Tim could not be stopped.

I needed to find a nearby location that looked like the salt flats. We looked for a desertlike area that was visually "loaded" (i.e., one that had some scenery) and that would set the futuristic mood I wanted. I chose a site that had an interesting dead tree, and was flat and dry like the salt flats. I used one Dyna-Lite head, powered by a small generator, to freeze the action and light Tim as he ran slowly across the desert floor. I also had the challenge of resolving the exposure difference between the sky and the foreground which I solved by using a graduated filter in front of the lens. A sky-grad filter reduces the brightness of the area of the image where the grad is placed. I chose a tobacco-colored grad to add some color to the sky, which played well with the tonality of the landscape. It all worked; this image ran as a double page spread in the magazine.

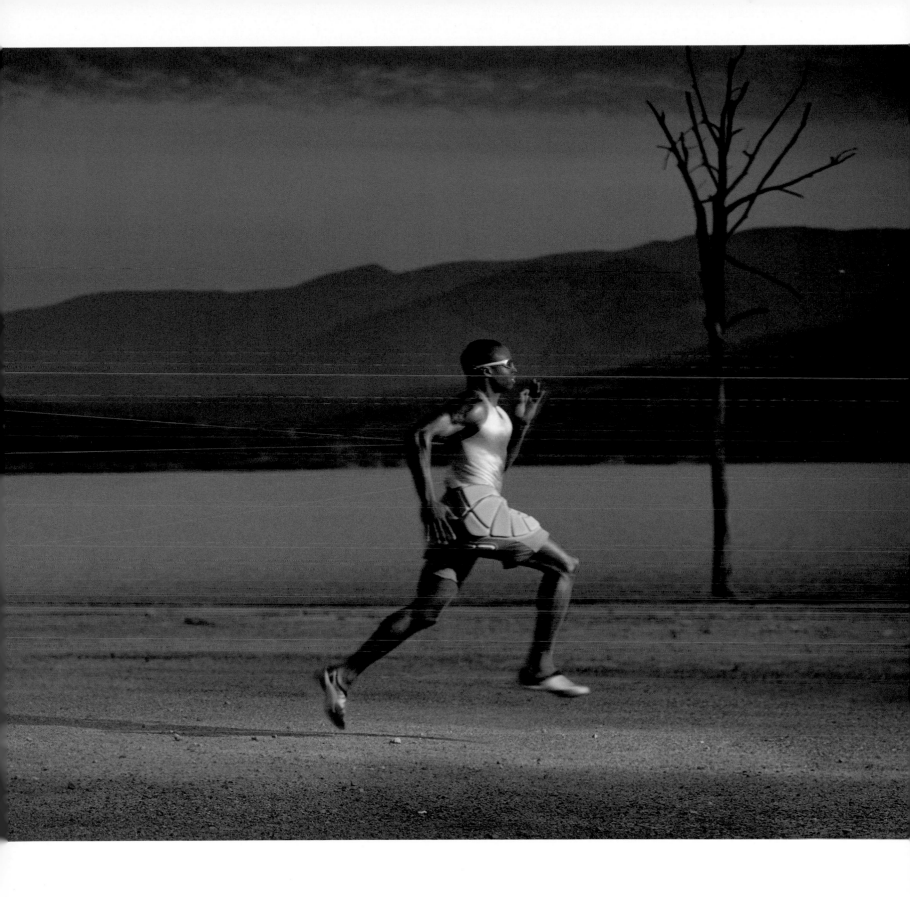

Studios & Sets

Sets are another tool that will help you tell your story and set your mood, without having to travel around the world to do it. The advantage of living near Hollywood, as I do, is that you can create any set your heart desires, even if you are on a budget. Usually, I like my sets to look like real, existing environments rather than fantasy environments, because to me, reality is strange enough. I like to juxtapose reality (or setups that look real) with people in odd situations. To me, that is more interesting than trying to make images that look like fantasy.

This set was an obvious choice for the portrait of Steve Sanford of icebox.com. But, what makes the set more interesting than obvious is that, while the icebox is real (it's a broken freezer from a prop house), nothing else in the set is. The ice cubes Steve's sitting on are clear plastic. I placed a little pocket flash on a slave inside the freezer to give the ice cubes depth and to make them look clear. The icicles on the wall in the background are props that glue on and can be positioned anywhere. The frost covering his hair and clothes is Epsom salt applied by a makeup artist. Even his face was made up to look cold and neutral in color.

Because the entire freezer was made of reflective metal and glass, I wrapped it in white seamless paper and bounced strobes into the seamless for the main lighting. In fact, I surrounded the entire front of the freezer with seamless, leaving only a small seam in the front for me to shoot through. I then "sneaked" the lights in, with varying degrees of blue gel on them, so you can't see the lights in the reflective surfaces. (What you actually see reflected in is the evenly lit seamless paper.) The power of the lights was set very low because you are seeing a direct reflection of the lit surface; if they were too strong you would not see any color, just blown-out white areas. I lit Steve's face with a single grid spot with no gel on it. His face picks up just a little bit of blue from the surface reflection lights bouncing off the seamless paper. That was all I needed to set the mood and tonality of the shot.

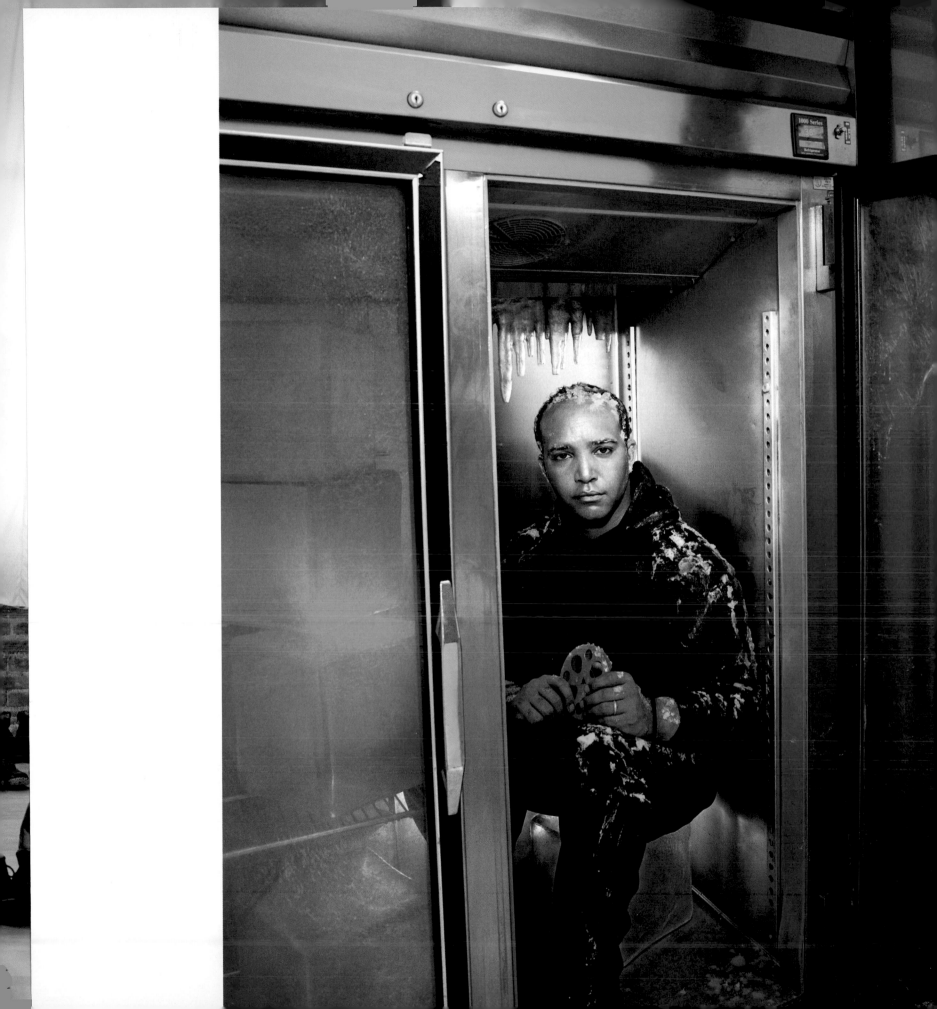

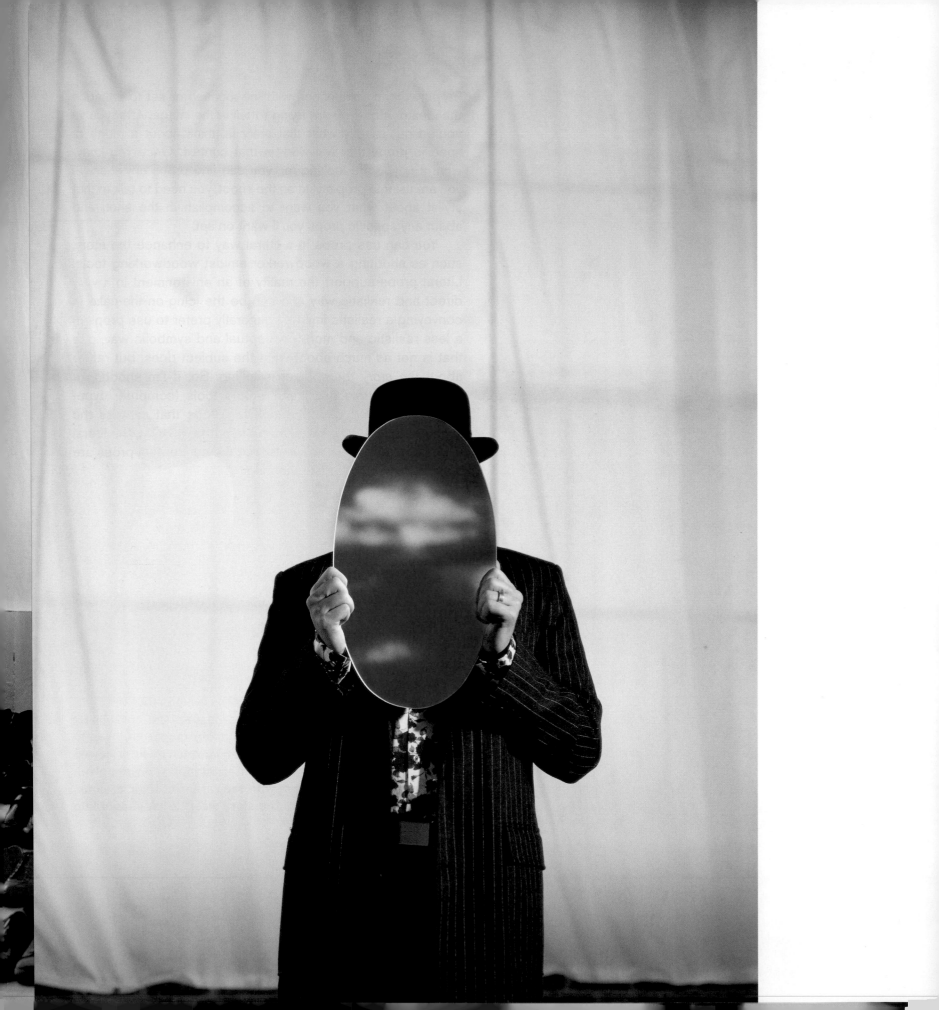

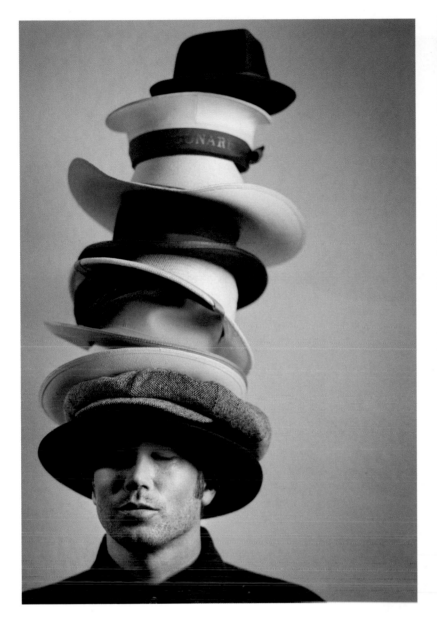

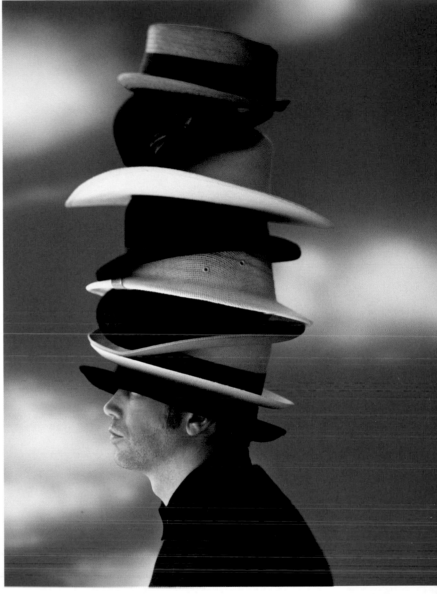

In my discussions with the creative director, Patrick Mitchell, and the photo editor, Alicia Jylkka, it became clear that the props should not be limited to desk or office jobs; I had to open up the notion of career possibilities, conceptually. The idea of using of hats and shoes came into play, and the concept then became clear: "What new hat will I wear?", "What new shoes will I fill?"

For the cover, I planned to shoot what the client had asked for: a simple portrait of Po. My idea was to shoot Po in a room full of different shoes he could try on and then with a bunch of different hats. I'd also brought a mirror along with the thought that Po could hold that mirror over his face in some shots, an homage to Rene Magritte, and a way to "reflect" the sky-is-the-limit theme. I shot the image of Po with the hats in black-and-white, as planned, against a very simple white wall, selected for its graphic strength. We were all having such a good time that Po decided to show off by walking around the studio with all the hats balanced on his head. As he walked past the blue-sky background I saw it: this is the perfect image for the cover of the magazine. I quickly re-lit and got the shot, and, it did become the cover of the magazine. This high-concept story, which was a pretty difficult thing to get across, was ultimately illustrated with some of the simplest props imaginable.

Makeup & Hair

Since I am a portrait photographer, I almost always have to make my subject look beautiful, and I use makeup and hair styling to enhance a subject's look. Because of the hard, dramatic way I often light, the makeup and hair must be done in a way that softens the potential harshness of the lighting. I do use makeup creatively, but in a more subtle way—like whether an actress' skin should be shiny or matte, or what color lips might work best with the wardrobe. All of this is discussed before the shot with the hair and makeup stylists.

Makeup and hairstyles, like fashions, change all the time. To stay on top of what is happening, a good photographer has to follow the trends by watching what's being done in the fashion magazines. I personally look at as many magazines as possible to see what is going on with trends in photography, but also for trends in hair, makeup, and fashion. For me, the European fashion magazines always push the limits of the medium farther and are more inspiring to look at than their American counterparts. I will often go to the newsstand and gather hip, hot, young magazines like *Razor* or *Black Book*, along with copies of mainstream publications like *Spanish Vogue*.

I had the privilege to shoot the brilliant actor Laurence Fishburne for a "20 Questions" interview for *Playboy*, which covered both his successful career and abundant acting ability. In my pre-shoot research, I learned that this actor's actor never stopped honing his craft, always pushing himself to the next level. I knew my image had to illustrate that sense of constant evolution, and I arrived at the idea of using a Japanese Kabuki mask to express it. I originally wanted to paint just half his face, but Lawrence insisted on going all the way, a choice I agreed with. I lit him with my Fresnel and just let him do his thing. He ran a gamut of poses for me, from emoting in a chair to hanging loose to smoking a cigarette.

Letting Go

Okay, you've made plans for your shoot tomorrow. You had a set built, special props made, and you asked the stylist to bring very specific wardrobe. You even sent the hair and makeup people swipes (tear-sheet samples) of the look you wanted, via rush messenger. Then, when you get to the shoot the next day, the talent arrives and won't have any part of it. They hate the concept, hate the clothes, and they are pissed off because you didn't use the hair and makeup people they wanted to use. What do you do? (And the answer is not, "cry.")

Sometimes, to make the shoot work, you have to let your preconceived ideas go and "punt," as they say. Letting go is the first step, psychologically, to moving on, and working towards a solution. This whole industry is solutions-oriented. You have to be able to adapt to new circumstances, new ideas, and new demands constantly. Schedules continually change and clients' requests can be moving targets as they try to figure out what they want. So, when the talent hates my concept, I turn to him or her and say, "OK, what do you want to do? What ideas do you have?" Once that conversation begins, the whole tone and tenor of the day usually turns around, because the talent feels included. I try to play off his or her ideas and see if I can work some of my original concept back into their scenarios. I have even occasionally been surprised by how great someone else's ideas were, and just moved on and shot them. Sometimes someone's resistance can make your idea even stronger, or, bring you to do something that might never have occurred to you. With creative people, you are often on a wild rollercoaster ride; if you hold on too tight to your original concept, you'll exhaust yourself, and if you completely let go, you'll get banged around or knocked out of the car. I try to ride the line between convincing the subject that my concept will work, and listening to and absorbing his or her ideas.

I was assigned to shoot Chris Farley for the first-year anniversary issue of *Bikini*. Chris was about three hours late because his flight from Canada to LAX was delayed. When he arrived, he was wired and ready to go. He spent most of his time during the setup flirting with his PR person, so after a few frames of just Chris and the cake, I decided to go for it and added a little sexy suggestion of the PR agent in the frame. It worked beautifully and made a memorable cover.

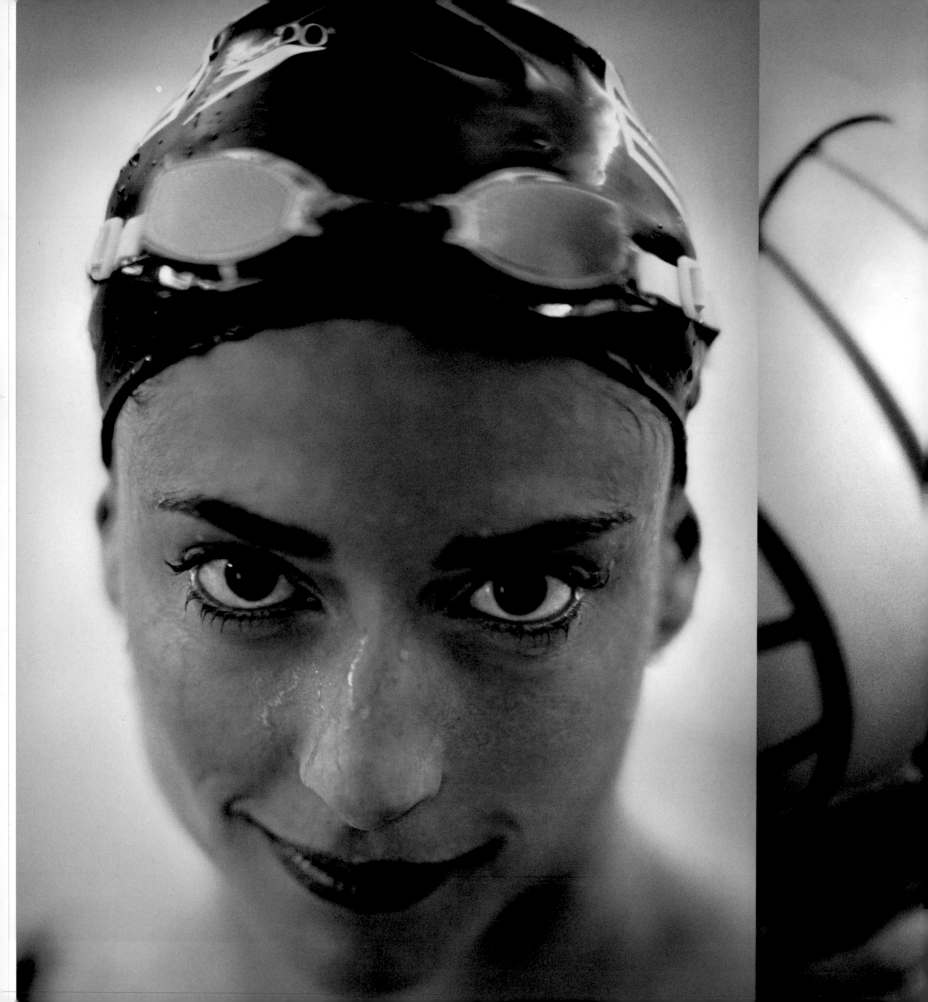

The Connection

Case Studies

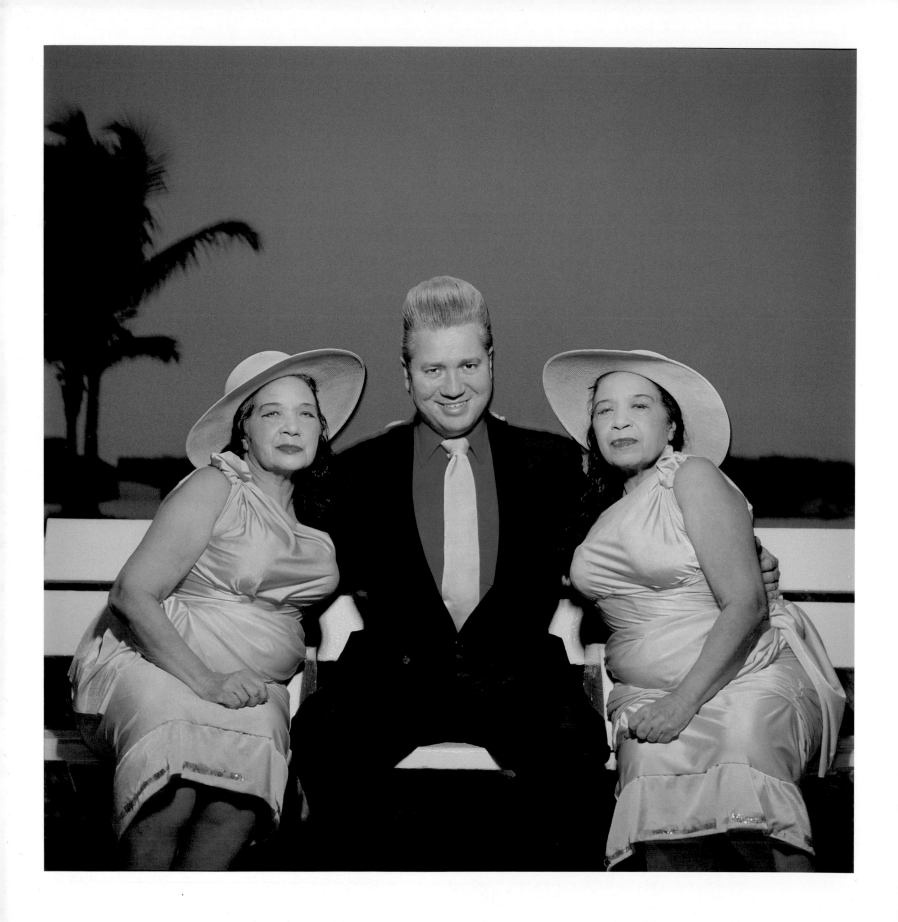

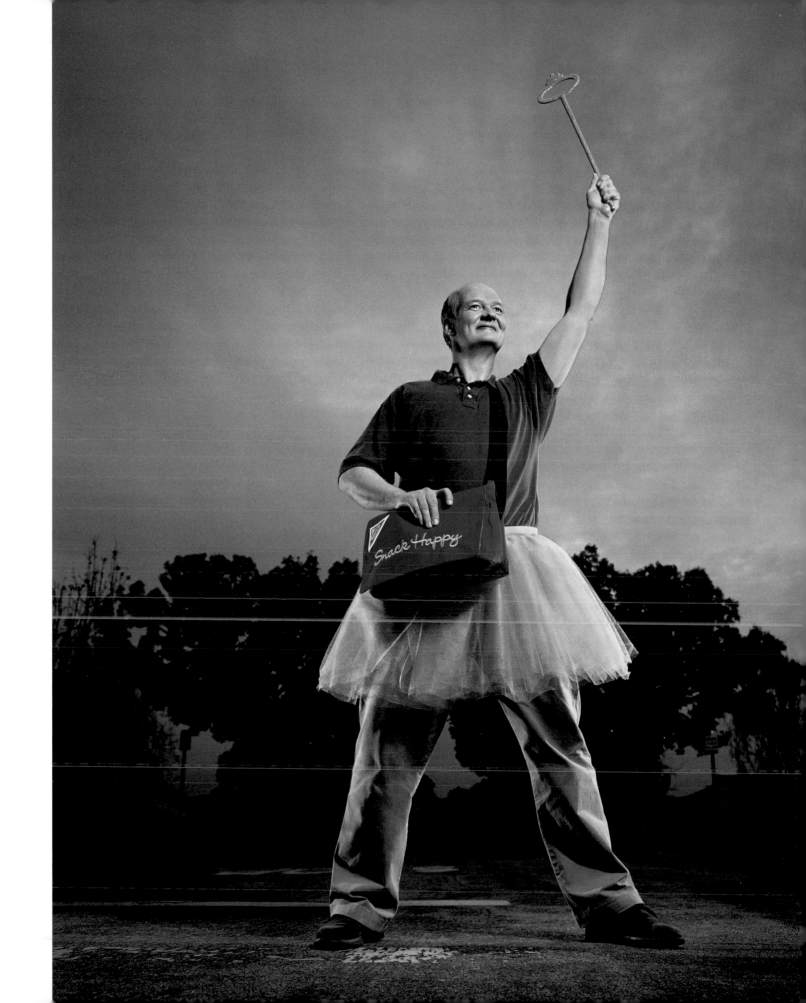

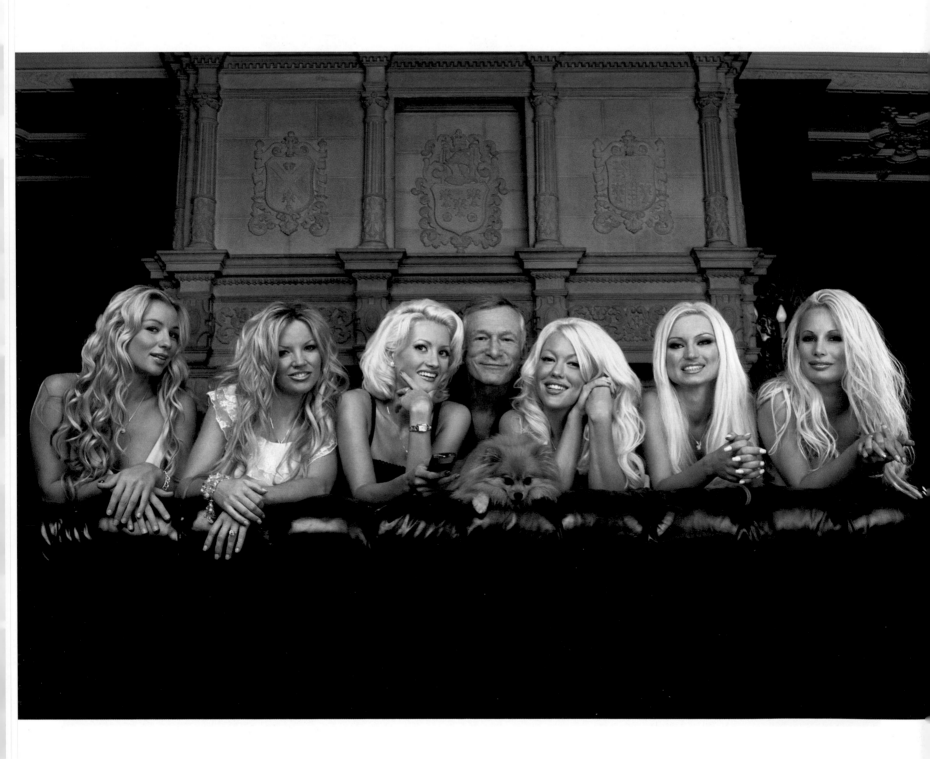

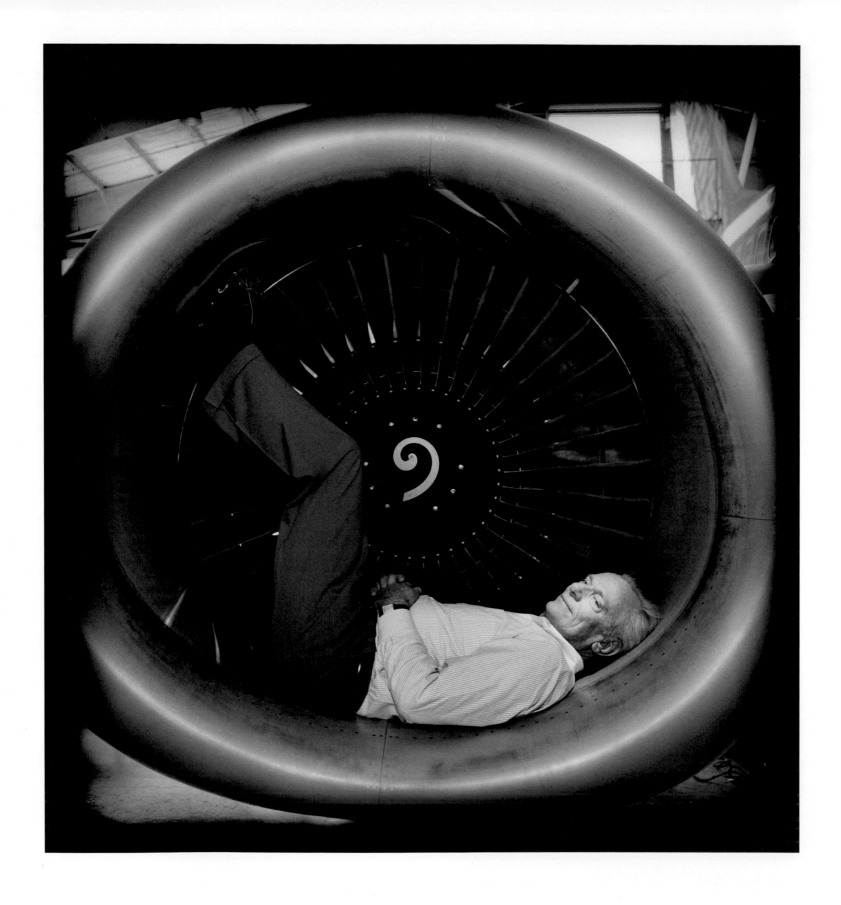

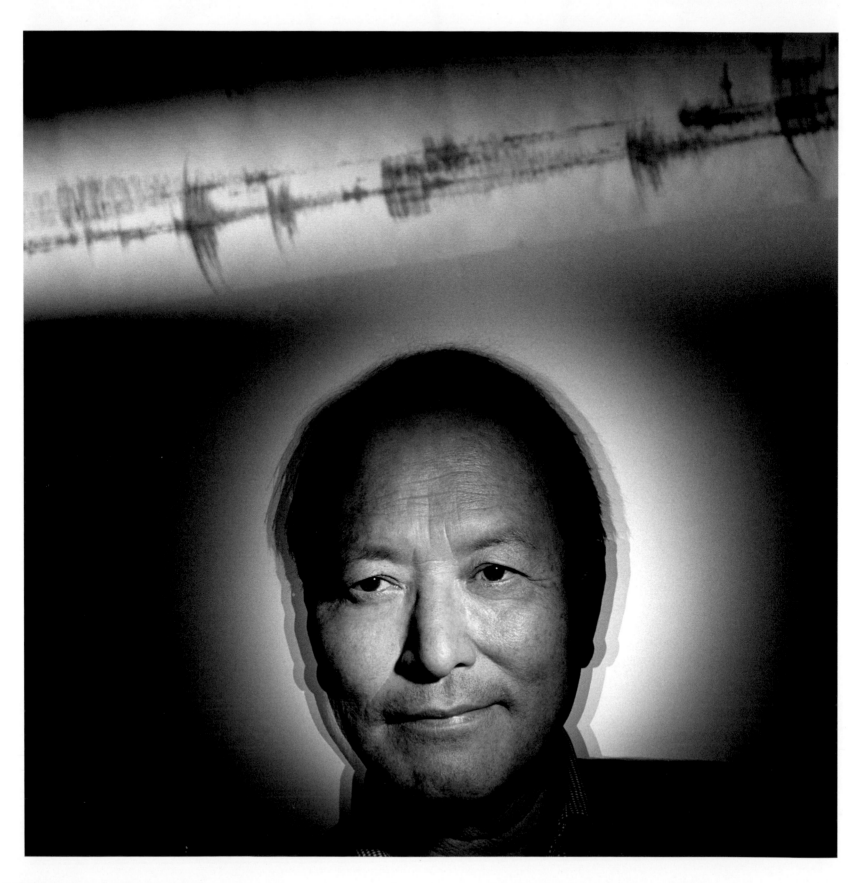

Page150, Randal Lawson: This image is the quintessential business image for me. It combines all of the things I am interested in: graphic lines and shapes, mystery, subject content, and dramatic lighting. The funny thing is, it was a job for a small computer magazine that I initially regretted accepting. It was not until I was about to walk into the building and saw the reflection of clouds in the circular window that I became excited about it. I wanted to blend the subject, Randal Lawson, into the environment, making them one, and I knew I had to shoot him through the window to accomplish that. The technical challenge was how to catch both the reflection of the clouds and him.

I solved it by lighting the subject and "mixing" the exposures. I knew if I put enough light on the subject, it would overpower the reflection of the clouds in the window just enough that you would see him through that reflection. I placed Mr. Lawson far enough behind the window so I could position a light to illuminate the front of his face, and then played with the strobe intensity, looking at Polaroids to get the right balance between the face and the clouds. At the same time, the image became a double exposure, using both the transparent quality of the glass, and its reflective nature. To emphasize the graphic quality of the shot, I also lit the green architectural detail above the door. This image always reminds me of why it's worth it to go out and try things even if you are not sure of the outcome.

Page 151, Richard Branson: The photo of Richard Branson was for a special issue of *Business Week* called "The Enterprise Issue." I had to do full-page portraits of the ten most important entrepreneurs of the time for a portfolio called, "The Entrepreneurs Who Make a Difference." The magazine had seen my Holga-esque photos of John Singleton and LL Cool J. The director of photography, Larry Lippman, and his associate Scott Myln, and I discussed how we could translate that Holga look to a business portrait.

When I got to Richard Branson's place in London, I immediately spotted this incredibly ornate mirror in the hall. The cherubs made me think of the "virgin" in Virgin Airlines. I also found an airline award he had received—a big airplane on a stand. We quickly pulled it apart (I always bring some tools with me) and I came up with this shot. The mirror was hung high (and too heavy to remove), so Richard had to stand on a box to fill the frame nicely, and I stood far enough away from him, on the same side of the hall, so I did not see myself in the reflection. I lit the mirror and him with grid spots, and as I was shooting asked him to look up and "fly."

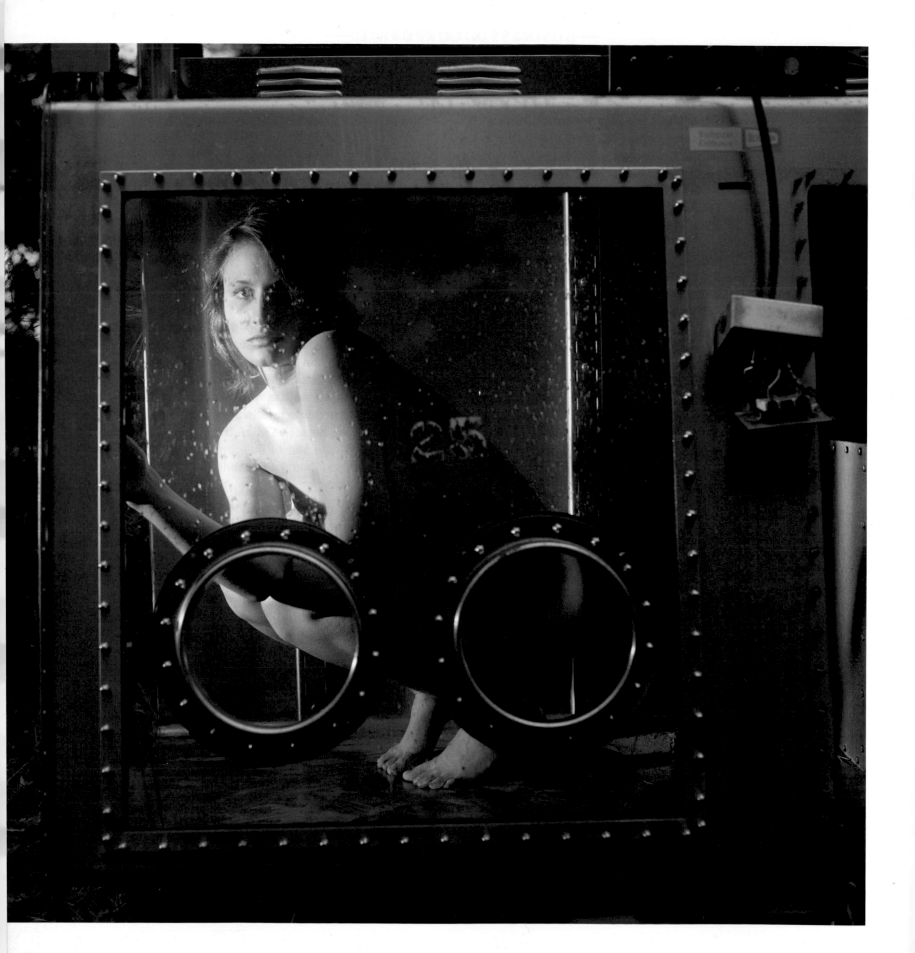

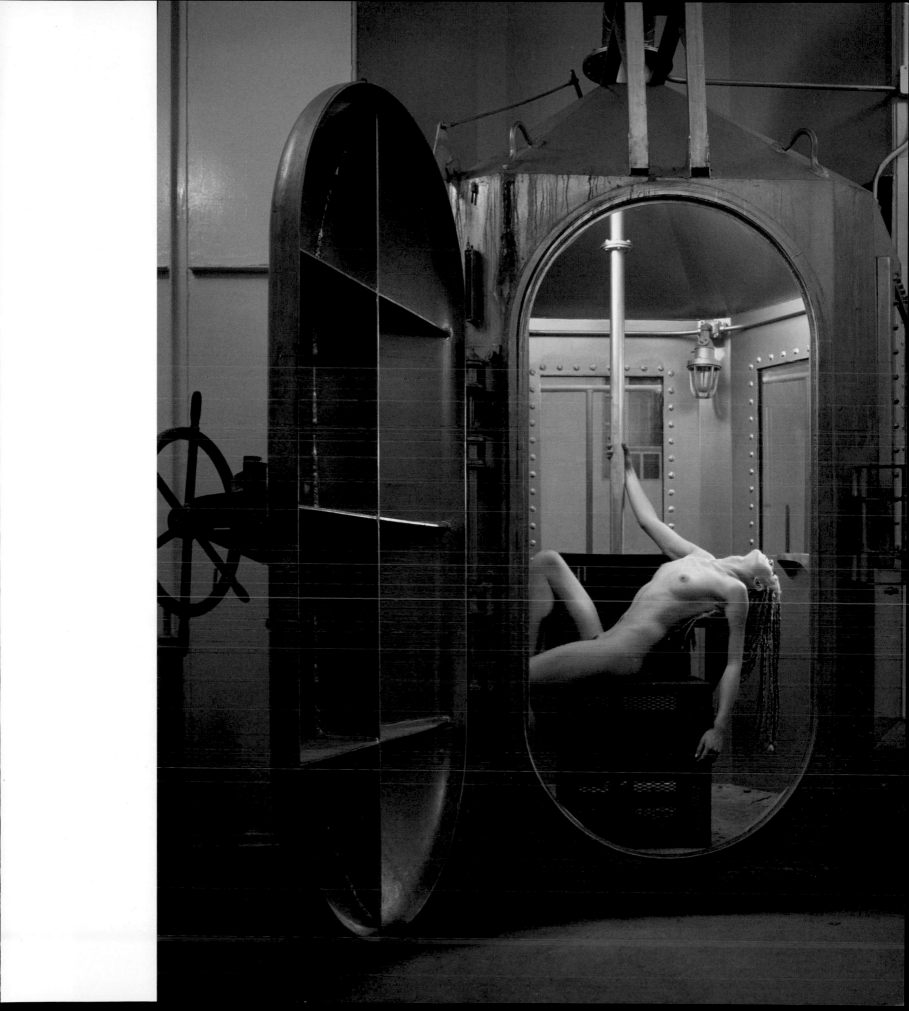

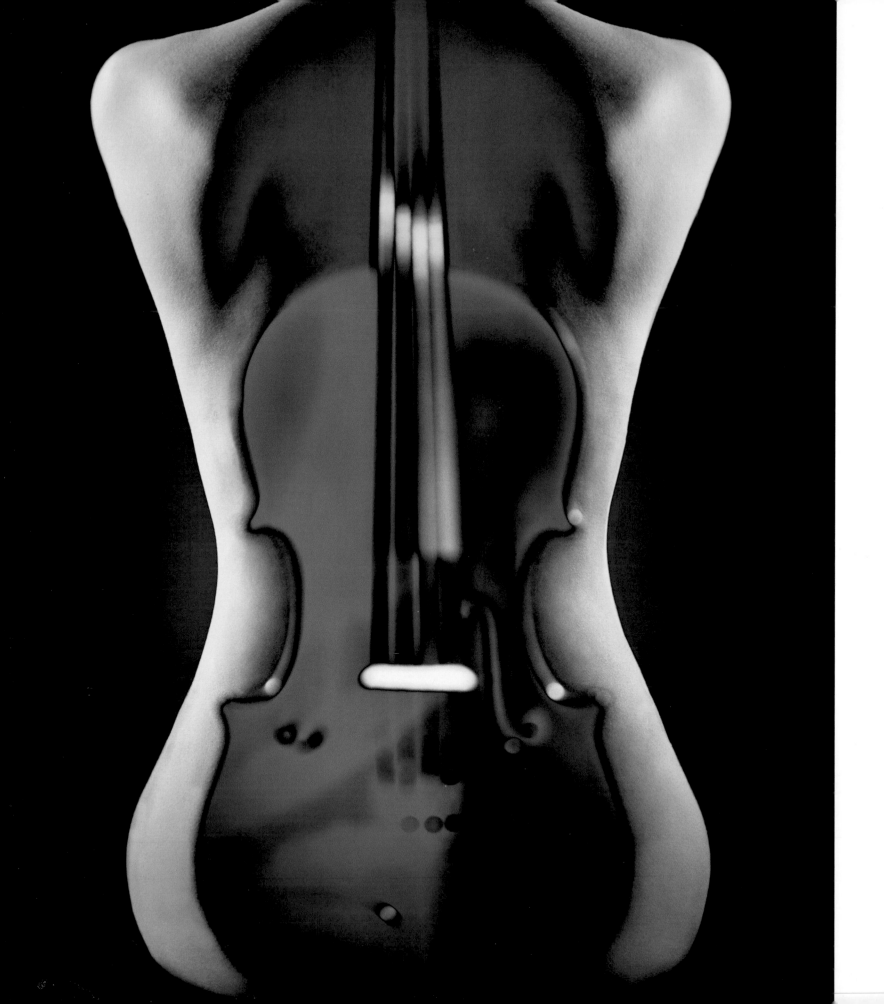

 Page 162, Jill in the Box: This image was an interesting self-assignment. Several times over the past ten years, I've taught at the Santa Fe Workshops, an ongoing series of creative courses for photographers. One year, I got back to the workshop director too late, and he booked Albert Watson to teach my portrait slot. At first, I was pretty disappointed, but instead of walking away, I decided to take the class. This photo was taken for Albert Watson's only assignment that week—to shoot anything you wanted to.

Since I tend to shoot people who would rather not take off their clothes, I thought I would do a nude. Someone suggested that an interesting location might be the Los Alamos Nuclear Labs junkyard. I did not know what I was going to do, but set out with an open mind. I found a metal box that was once used as a containment unit, the type where you slip you hands inside, through gloves, from the outside. The side of the box was open, so I had the model get inside and I shot her through the glass front; you can see the two round holes where the gloves used to be.

As we were shooting, the sky turned to gray and it started to rain, so the light became blue in tone. Instead of fighting the color change, I went with it and enhanced it by using tungsten-balanced film to make it even bluer. I then added some CTB, or half Booster Blue, to make her skin tone go blue. (CTB filters are used to convert tungsten lights to daylight and come in varying strengths, a full being a complete conversion to daylight.) Even with tungsten film, most skin tones won't go blue without blue on the lights (in this case, a Comet PMT 1200). The rain and the sky color add the right mood to what my assistant has entitled "Jill in the Box."

 Page 163, State Pen Nude: This image was shot a few years ago while I was teaching at the Santa Fe Workshops, at the gas chamber at the former New Mexico State Penitentiary. Once I heard that it was available as a possible location, I flipped—what an amazing place to juxtapose something so beautiful with something so sinister. To me, the most interesting thing about this ominous piece of low-tech machinery was its silvery quality, from what looked like silver spray paint. Lighting the environment, I wanted to keep the silver look.

The room was lit with bounce strobes off the ceiling, with slightly different variations of blue and green gels. The gels were also very light in density, so that the added color would be subtle. The lights were bounced into the ceiling, the chamber itself, and the room behind it, so that the image had depth and the windows did not fall to black. I want to go back there sometime because I have few more ideas swimming in my brain . . .

 Page 164, Violin Nude: This is an example of the use of a nude as object, a play off of the Man Ray image of a nude with violin clefts painted on her back. Since the violin had very shiny surfaces, I chose to light it with big soft light boxes. To keep the images dramatic and interesting, I placed many of those sources at obscure angles. Here, the light almost wraps around both the figure and the violin. But, I encountered a problem—positioning the lights so they made the nude look great did not illuminate the violin enough to read on the film. And, if I brought the light forward more, to light the violin more fully, I would lose the dramatic line of the figure. So, I added one small spotlight, just on the violin, to bring up the exposure. The light came from the extreme side so that we did not get a direct reflection off the shiny wood surface. Since these were solarized images, I played with the focus to accentuate the look of the solarization.

Page 166, Holiday Inn: The concept for this ad for Holiday Inn was funny—a kid in the tub, who had made animals and objects out of shaving cream. The idea was that Holiday Inn would bring you anything you need, even more shaving cream. I hired both a model maker and a food stylist. The model maker built Styrofoam bases for each object to give them body and substance and a surface the shaving cream would stick to; the food stylist sculpted shaving cream over the bases.

My brother, who is a contractor, built this set for me. The client wanted to use white tile, because that's what's in their hotel rooms. I fought against it because I wanted the shaving cream to stand out against a darker color. We compromised on a difficult-to-find blue matte-finished tile. (The matte surface would make it easier for me when dealing with lighting reflections.) I lit the set from above to achieve the natural feel of a ceiling light, but I also did it to separate the shaving cream from the wall, giving it dimension. To light the boy's face, I ran tape across the foam-core board, making the window shadow. I added opal (a very thin diffusion material) to some of the "panes," and tree leaves as a gobo to alter the light. The final light was a silk with a head behind it, which acted as a big fill in the front. The fill enabled us to control the depth and level of the shadows from the overhead light. By the time we were done, It, looking nothing like window light (there are no windows in Holiday Inn bathrooms), brought out the kid's face.

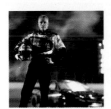

Page 167, Mark Martin: This was an ad campaign for Viagra featuring Nascar legend Mark Martin, shot on a day where we had to do what's called a "shoot around." (That's when the art director is not sure of exactly what he or she needs, and has you shoot everything possible.) We shot like crazy all day. This was the last shot, at the end of the day, and we had lost the light in the sky. I took the risk of side-lighting him from both sides; I figured the light was gone and I had nothing to lose. I placed two Dyna-Lite heads and packs on either side of him, mirroring their positions. (We Polaroided to make sure the lights were exactly the same on each side.) I also read the ambient light in the scene so I could figure out how long the exposure time should be. We went down to about a two-second exposure, but the sky was still falling darker than I wanted. I added smoke to the shot, way in the background, to pick-up some of the ambient track light and help open up the sky. Then in post, I had the color of the sky lightened just a little bit more to get exactly what I wanted.

Page 168, Nortel: This was an ad for Nortel, the makers of the game *Cranium*. Our subject, Richard Tait, was the game's inventor, and the challenge was to shoot him to look like he was actually upside-down, when, in reality, he was shot upright. The shot was done in two parts that merged together seamlessly, and it worked as a horizontal two-page spread, a vertical single-page ad, *and* a 40-foot long airport Duratrans. I had a long set built that was simple yet looked and felt rich. I lit the set flatly at first, thinking that that would be best for the composite, but I did not like the look of it. We re-lit with a hard, directional light, and measured its height and location relative to where our subject would go. I then shot different sets of legs, arranging the pant creases so I could clone them and have as many different pairs of legs as I needed.

I had the set builder pick up some gravity boots and a sturdy pipe we could hang Richard from, and I shot a safety roll of film and a few reference Polaroids of him upside-down so I would know what I needed to do with him to make the composite shot look real. I had the set people make a section of the floor that matched the floor where Richard would actually be positioned. The special-effects hair artists studied the Polaroids, and stuck Richard's hair to the upside-down piece of floor, rigged just above his head. The wardrobe stylist taped his clothing so it would hang exactly the way it did in the reference Polaroids. I lit him according to the measurements we took when we shot all the legs, although instead of the light being five feet off the *floor*, it was now positioned five feet from the upside-down flooring on Richard's head—exactly as it would have been if we'd been shooting him actually upside-down.

I shot a lot of different expressions and poses. The agency and I picked the expression we liked, and then the retouch technician matched the parquet piece on Richard's head right to the parquet in the leg shots.

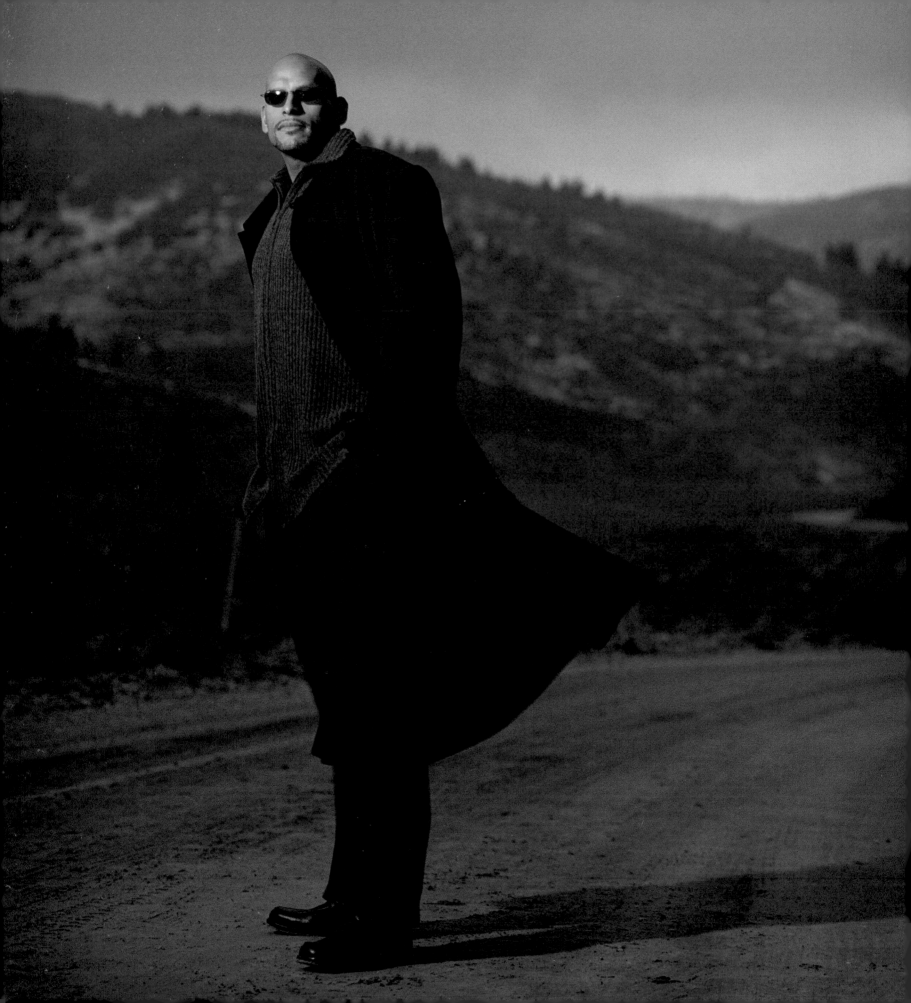

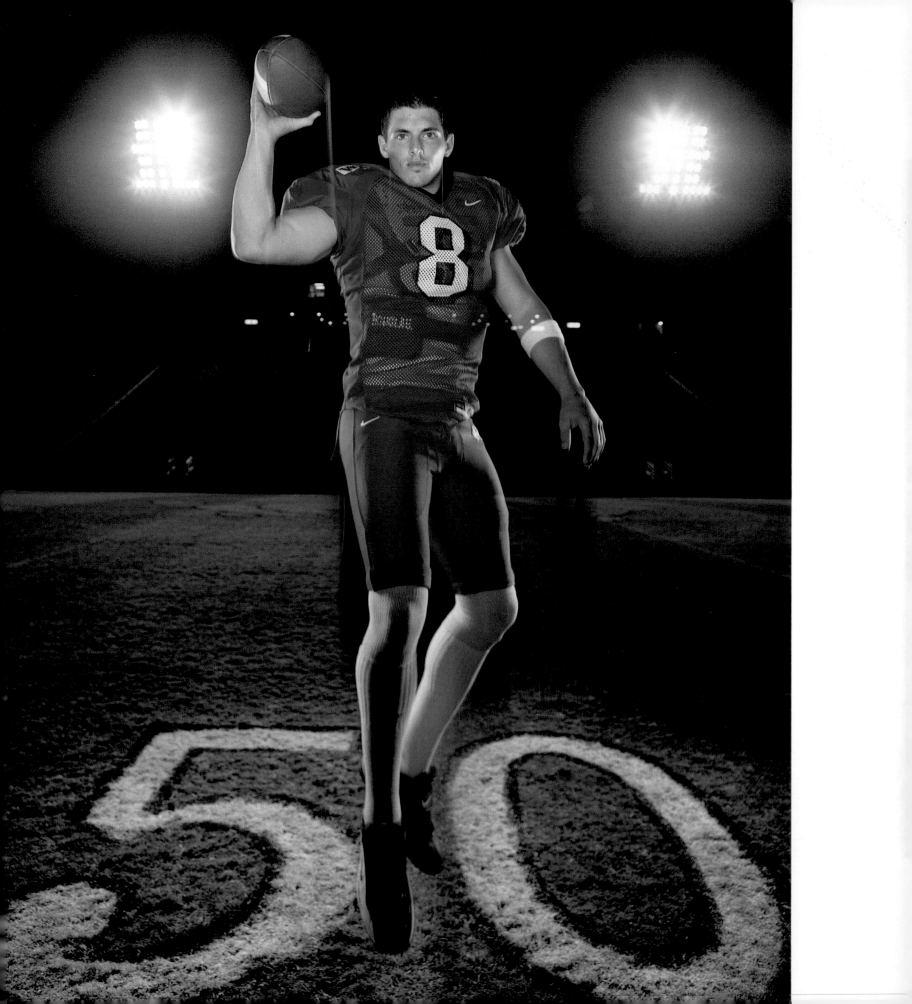

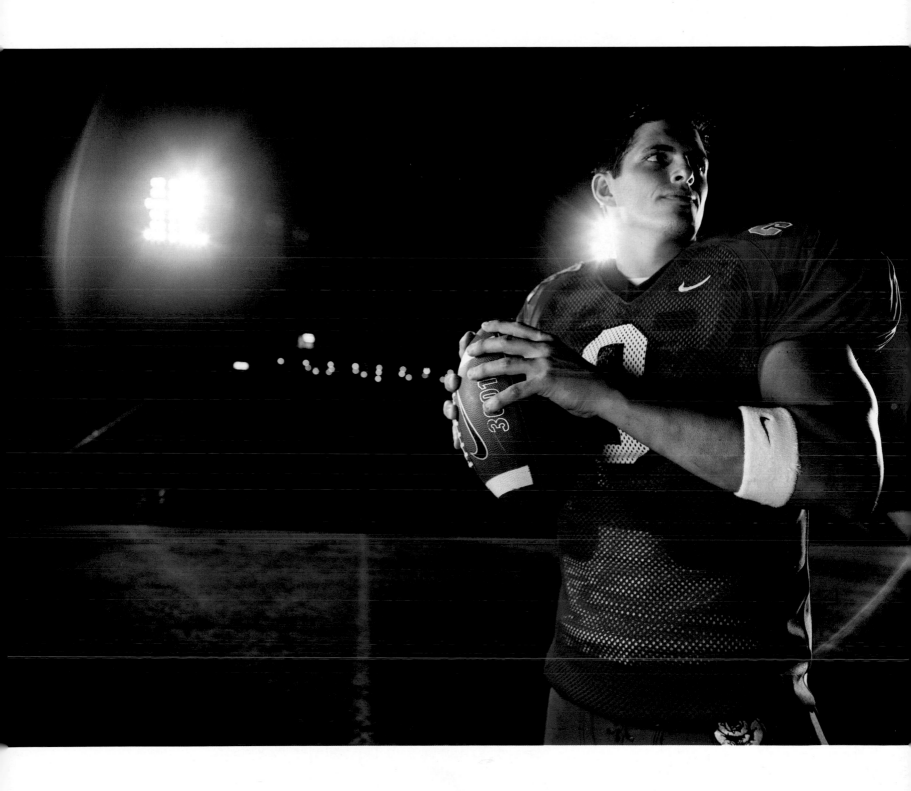

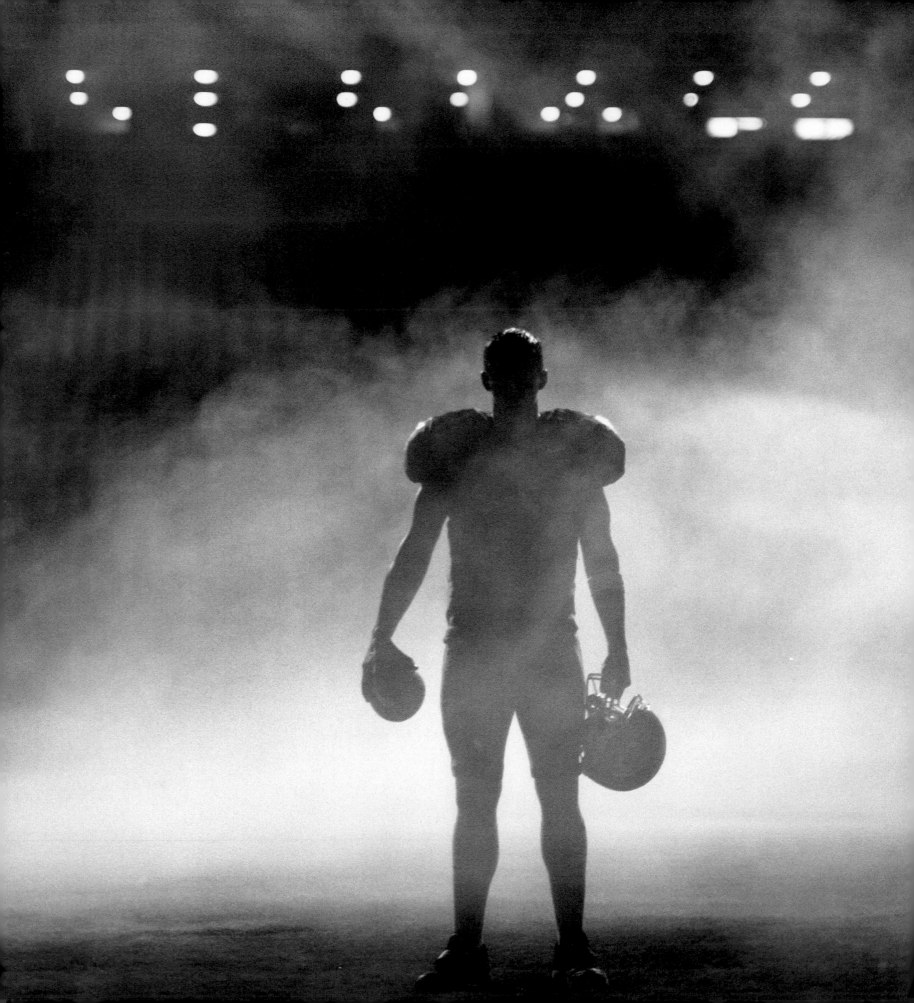

Pages 170–171, John Amaechi: I particularly love the sports portrait because my preference for dramatic lighting and creative license generally works well with the content of the images. *ESPN The Magazine* asked me to photograph Utah Jazz basketball player John Amaechi, the lone Renaissance man of basketball. We shot him in and around his home, with his paintings and other art, and then drove to a pre-scouted location and shot him on this road. The lighting was simple—one head with a wide grid spot, blended to work with the ambient exposure of the light in the scene. I had to continue to open up the shutter speed throughout the shoot, as evening fell around him.

I set up a pool of light that John could step in and out of and I positioned myself at a place where the road made a shape that would look great in the horizontal frame of a double-page spread image. I had John walk into the light several times until I felt like I got the shot, maybe about five or six rolls of 120 film. The way the wind machine blew his wardrobe around and completed the desired feel of the shot.

Pages 172–174, David Carr: These shots were for a feature story I did for *ESPN The Magazine* on star Fresno State quarterback, David Carr. Editor John Toolan and I decided to shoot at night in David's home stadium; we wanted to capture the feeling of those stadium lights in the background, and the ambience of the stadium itself. I brought a fog machine, knowing that just a subtle bit of smoke in the air would accentuate those lights, yet not make the scene look fogged. It would also help soften any flare from the lights, because the lights hit the smoke first, not the lens optics.

To create a sense of place, and as a graphic element in the shot (page 172), I set up at the big 50 at the 50-yard line. Knowing that the background lights would not give a lot of rim light on David himself, I added two vertical strip boxes in the background as rim lights around him. These created the look of stadium lights, but they also spread to the ground and illuminated the 50 on the field. I gelled them, mixing teal and blue to give a cold feel to the shot. I took a bare head high in front of David, added a wide grid (40°), a piece of Hampshire Frost (very subtle diffusion), and a blue gel as a face light. The grid kept the head from spilling all over the place, and kept a central hot spot; the frost took a slight bit of the harshness off the light and the blue gel kept the mood I wanted.

Because of the long exposure (to burn in the stadium lights for atmosphere), I had to make sure the modeling light was off on the strobes, to reduce the effect of the ghosting around David, as he jumped up and down. I needed to capture him at the top of the jump for the power of the image. I also did a trick with the Fuji 680 camera body, which I often do when shooting action—I locked the mirror up. The mirror is so big there is a delay in the camera's firing—it takes a few milliseconds for the mirror to get out of the way before the camera will fire and, by the time it does you have missed the peak of the action.

I did the horizontal image (page 173), coming in very close and purposely catching the flare from the vertical rims lights I'd set up. Flare can add atmospheric quality to an image. As I was shooting, one of the assistants had to use the restroom across the field. As he returned, I watched him walk through the fog of the fog machine, which was way downfield, and I knew that this would be my next shot (page 174). I begged David for five more minutes. We ran everyone to the end of the field, and I made this image with a long exposure in the natural light of the stadium, with my camera on my tripod. It was used as the closing image of the story.

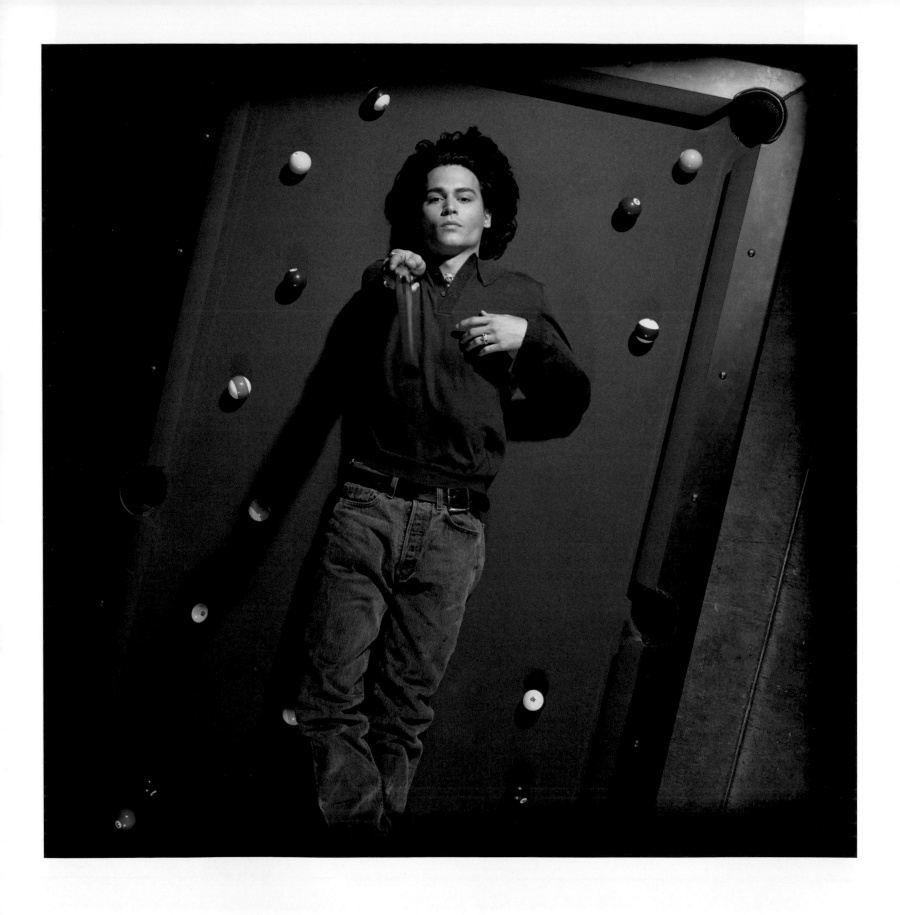

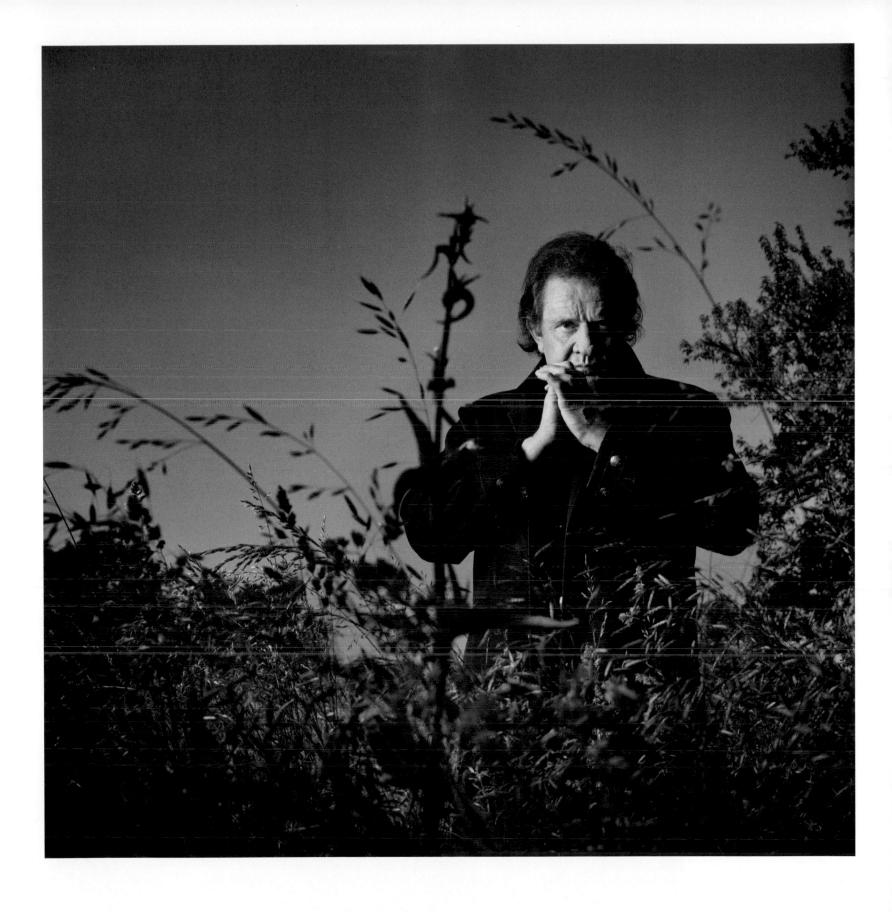

Duvetyne
West Coast term for cotton fabric used to make flags, cutters, a solid butterfly, and overheads; called commando cloth in the East Coast.

Extension arm (gobo arm, grip arm, or extension grip arm)
A tube with a 2½" grip head permanently attached. The Matthews extension arm has a stainless steel shaft with a ⅝" outside diameter, which allows a standard, baby light fixture to be mounted on it and used as a boom.

Finger
A small, rectangular thin-wire frame covered with bobbinet, silk, or Duvetyne for lighting control in small areas on a set.

Flag
A rectangular frame with a mounting pin made of ⅜" thin wall tubing onto which Duvetyne is sewn. Flags are used to create shadow areas on the set.

Flex arm
A flexible mounting arm with four or five lockable ball joints for mounting dots, fingers, or flex screws.

Floppy cutters
Made with an additional panel that is held in place with Velcro™ when not needed and released to double the size of the cutter when needed.

French flag
Either made out of a firm but flexible ABS plastic and used to shade a camera lens with the help of a French flag arm, or made of steel and used on a flex arm, which is attached to a light fixture.

Furniture clamp
(*See* bar clamp)

Gator grip (gaffer grip)
A clamp with an adjustable jaw equipped with twelve rubber gripping pads that protect the surface and provide greater clamping ability.

Gobo ball
A bright orange foam ball which slips onto protruding extension arms to prevent injury to eyes and other sensitive areas of the body.

Gobo head (grip head)
Used to mount and attach extension arms, flags, cutters, etc. on top of a stand.

Grieb arm
A flexible arm which can be bent into almost any position to hold a French flag, dot, finger, flex scrim, or flex clamp.

Grip
Our main man on the set-responsible for rigging cameras, the safe operation of camera cranes and dollies, not to mention camera cars. Grips erect sets and do non-electrical lighting control.

Grip head
(*See* gobo head.)

High boy
Slang for Hi-Hi roller or high overhead stand.

High hat
A very low-mounting adapter for camera heads, usually mounted on a wooden board.

Inky
300-watt Mole light fixture.

Junior
A 2000-watt or 2K (or larger) light fixture. The standard junior is made with a 1⅛" pin attached to the yoke or bale, and gets mounted into a female receiver on the stand. It is the opposite of the baby mounting system for safety purposes.

Key light
The main light source on which the entire lighting plot is usually based.

Lamé
Silver or gold laminated to a knit tricot fabric, in sizes up to 20'x20'; used to reflect light.

Lettuce
Single-wire diffusion. A double is known as a tomato.

Low boy
A term commonly associated with a low light stand.

Magic finger
A ⅝" baby pin mounted on a ball head that can be mounted to the top of any baby stand; will lock tight at any angle between 360° in the pan and 90° tilt. For safety reasons, neither the arm nor any of the attachments are removable.

Pancake
East Coast term for eighth apple box.

Pidgeon
East Coast term for baby plate or junior wall plate.

Pig tail
Short piece of electrical cable with connector plugging device at both ends.

Polito bracket
Made to hold expendable reflectors or beadboard and foamcore; can be adjusted from 24" to 48". It has an ear for mounting in a grip head; a ground spike, and a handle for hand holding.

Poultry bracket
Turns any pole (even a street lamp) into instant light stands.

Rags
Fabrics used on butterfly and overhead frames.

Rocky mountain legs (leveling leg or lazy leg)
Leg extension allowing the leveling of a stand on uneven terrain.

Siamese (Y connector)
An electrical pig tail, which has one male connector at one end and two female receptacles at the other.

Stair block (step blocks)
Made from 2x4 or 2x6 lumber stacked like stairs to raise furniture on a set.

Stinger
A Hollywood term for a single extension cord or a heavy-duty single extension.

Stirrup
A mounting device most commonly attached to telescoping hangers for the mounting of theatrical fixtures that have pipe clamps attached to yokes.

T-bar
A 40" long, 1¼" steel tube with a Junior (1⅛") pin welded midway. Often used for hanging theatrical lighting fixtures.

Tomato
A double-wire diffusion. A single is known as lettuce.

Trombone
A telescoping arm, designed to hang on a set wall with retaining arms that adjust to the wall's thickness for security.

INDEX